JOANNA ZOELZER

# WHY BEES DO NOT SEE RED AND WE SOMETIMES FEEL BLUE

## 150 FACTS ABOUT COLORS

Original English texts and German—English translation
by Eliza Apperly

**teNeues**

# CONTENTS

# FOREWORD

I was fascinated by color from an early age. Over time, I began to engage with the topic more intensively. I started to pay colors ever more conscious attention and became interested in their effect, history, and symbolism. It's always exciting to notice where we encounter colors in everyday life and how they influence us. Colors have an integral function in our lives, triggering particular emotions and containing information that guides and informs our thinking, feeling, and action. But why? Why is blue the most popular color in the world? Why is pink feminine and why is brown usually avoided? Why do colors appear in idioms? And where do color names come from?

The first color story I researched rigorously was about bees. I was completely amazed when I read one day that bees cannot see the color red. In fact, color vision in the animal kingdom has, through evolution, distinct differences. In their article *The Color Vision of Animals: From Color Blind Seals to Tetrachromatic Birds*, scientists C. Scholtyßek and A. Kelber explain that "many vertebrates, insects and crustaceans not only see the color spectrum that we can perceive, but also ultraviolet radiation (…)." Bees also perceive UV light, but not the color red. Snakes can recognize three-dimensional thermal images in the dark, thanks to their ability to perceive infrared radiation. This gives them a significant advantage over their prey. Marine mammals and some nocturnal mammals are completely color-blind. I was so intrigued by the story of bees' color vision that I started looking for more interesting facts about color.

Strictly speaking, color does not exist in nature. Rather, our sensory organs and brain create an impression of color. As soon as light rays hit an object, they are reflected back off that object and enter our eyes. The perception of color is only possible with the help of light; in the dark we can see barely—if any—color at all.

The common names to describe color are as varied as its shades. In most cultures, the first color to get a name was red. Color and its categorization has occupied artists, philosophers and scientists since ancient times. Aristotle experimented with light and colored pieces of glass. But it was not until Isaac Newton developed the color wheel in the 17th century that color theory was established. Colors are divided between the chromatic

(with hue) and achromatic (without hue). Three features or properties can be used to describe and distinguish chromatic colors from one another: brightness, hue, and saturation. Achromatic colors include white, black, and—mixed from these—gray tones. They are referred to as achromatic colors or non-colors and differ from one another only in their brightness value.

There are countless colors and no two are alike. The human eye with finest visual acuity is able to differentiate between around 200 different color tones, as well as 500 levels of brightness and white gradation for each color. In total, humans should be able to differentiate between 20 million colors. The assumption that color-sensitive people can differentiate between 100,000 and 1 million color nuances is probably more realistic. But here, too, there is no generally binding designation for the vast majority of colors. Instead, we use the six main colors—white, black, red, green, yellow, blue—and another five mixed colors—brown, orange, pink, violet, and gray—to name almost all colored objects and communicate color impressions. This book contains 15 chapters on the most striking colors, arranged like a paint box, from white to black. Metallic colors like gold and silver are also included. The last chapter "Multicolor" considers colorful phenomena that cannot be assigned to a single shade.

According to traditional color psychology, each color has its own character and effect. While some colors are classified as calm and harmonious, others are considered powerful or dynamic. Here is a brief introduction to the most important colors that surround us every day:

**White** symbolizes purity, clarity, light, and innocence. It is considered the color of perfection and represents morals and beginnings, such as with a white sheet of paper or a white wedding dress. White is associated with both positive and negative. It is the color of peace, but is also considered sterile and cold.

**Yellow** is associated with joy and happiness and is connected with youthful, intelligent characteristics. It is the lightest color that the human eye can see and attracts a lot of attention. Yellow also stands for warmth, cheerfulness, loyalty, and honor. The color stimulates mental activity, but in darker shades it can be linked to fear, cowardice, and betrayal. According to color psychology, yellow arouses the strongest emotions.

**Orange** combines energetic red and cheerful yellow. It stands for youth and fun, spontaneity and optimism, adventure and independence. Orange looks warm—no wonder; it is also the color of fire and the sun. The color stimulates both appetite and social interaction as it

appears encouraging and invigorating. Orange is used to catch attention on ambulances, safety vests, and road traffic signs—more on that later.

**Red** arguably attracts the most attention and is used to communicate warning. It is associated with energy, love, and passion, but also with danger, violence, and war. Red has a stimulating and invigorating influence on metabolism, breathing, and blood pressure. Symbolic of courage, revolution, and progress, red is the most popular color for flags, found on around three-quarters of all national flags.

**Pink** is the combination of red's passion and white's purity. It represents compassion, innocence, love, and romance. It can be feminine and kind, calming and encouraging. Depending on the shade, pink can also be perceived as garish and intrusive and associated with excessive emotion or immaturity.

In **purple**, the coolness and stability of blue are combined with the energy of red. Purple has always been one of the most expensive dyes and was traditionally reserved for the nobility and clerical dignitaries. It embodies luxury, extravagance, and power, but also wisdom, dignity, and individualism. Violet is also the color of magic and spirituality. It has a calming effect, but is also associated with melancholy.

**Blue** is most people's favorite color. It stands for life, like the blue planet, sky and sea. The color is associated with trust, reliability, wisdom, depth, and calm. Blue is a cold color with a concentration-enhancing and relaxing effect, but it can also intensify sadness.

**Turquoise**, a light blue-green, has the characteristics "cool" and "refreshing". The color is alluring, found in the sea, lagoons, and glacial lakes, and evoking travel and holiday. It radiates zest for life, a youthful energy and freedom, but can also be perceived as distant and intrusive. Turquoise is named after the semi-precious stone of the same name, which occurs relatively rarely in nature and is therefore sought after as a gemstone.

**Green** is the color of nature, growth, and hope, symbolizing fertility, harmony, and freedom. The color is calming and particularly easy to perceive for the human eye. Darker shades are associated with wealth, or with the military. Green is the color of security. Green traffic lights indicate that you can walk or drive. Escape routes are also marked with green signs.

**Brown** is one of the earth tones and is considered to be particularly natural. Forests, logs, and branches are brown and represent robustness, reliability, and familiarity. The color stands for warmth, coziness, and comfort, but

can also be perceived as old-fashioned and staid. Chocolate, coffee, and everything that comes out of the oven is brown or browned and associated with enjoyment.

**Gray** is equated with boredom, loneliness, restraint, and inconspicuousness, and is considered a symbol of sadness and worry. The color also stands for neutrality, willingness to compromise, and seriousness. In the automotive industry in particular, gray marks objectivity, functionality, and elegance. In interior design, gray is often used as a stylish and classic color.

**Black** is very ambivalent. It is associated with power and elegance, as well as death and evil. In fashion and design, the mysterious black is considered noble, stylish, and expensive. In everyday life, it sometimes causes discomfort and fear, associated with negatives such as grief, crime, and depression.

**Gold** is a marker of material wealth and luxury. It is considered valuable and noble. Due to its longevity, it creates trust, e.g. as an investment. Gold stands for success stories, recognition, fame, and honor, such as the gold medal. The gleam of gold is associated with a warming effect; it is reminiscent of the rays of the sun. Too much gold can be perceived as an excess.

**Silver** is also considered exclusive, but plays a subordinate role to gold. It symbolizes lightness, speed, technical progress, and has a modern look. The cool, reserved tone is perceived as distant and aloof.

**Multicolor** is the combination of different colors and emphasizes the positive associations of each one. It stands for fun, joy, liveliness, openness, and childhood.

For this book I have selected 150 color facts from different cultures and fields of knowledge to present the fascinating world of colors in my own special way.

—Joanna Zoelzer

WHITE

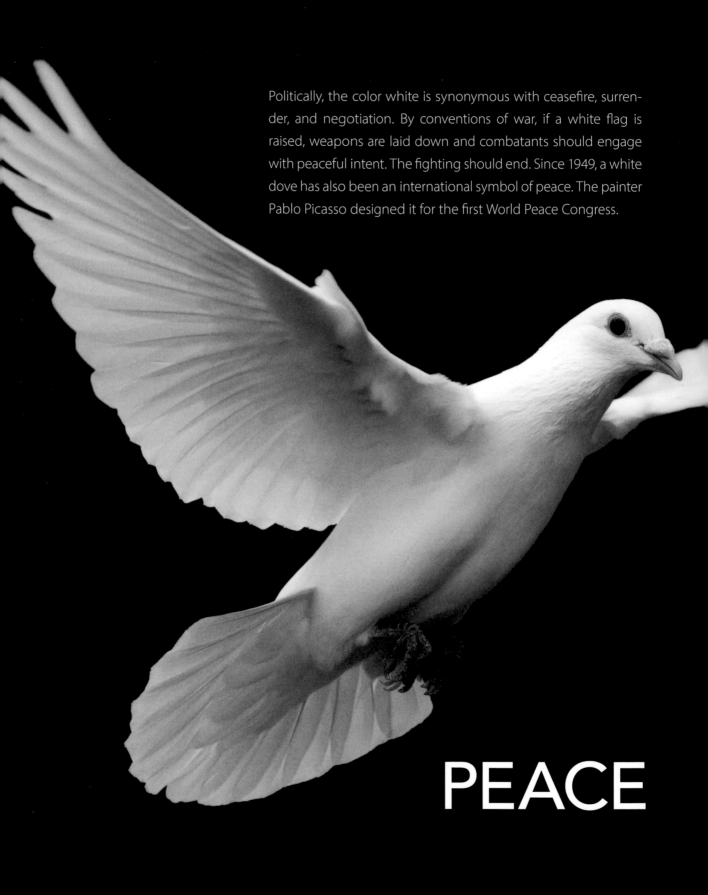

Politically, the color white is synonymous with ceasefire, surrender, and negotiation. By conventions of war, if a white flag is raised, weapons are laid down and combatants should engage with peaceful intent. The fighting should end. Since 1949, a white dove has also been an international symbol of peace. The painter Pablo Picasso designed it for the first World Peace Congress.

# PEACE

# COLOR
# OF THE
# GODS

White is considered the color of deities, and in many cultures white animals are considered as the living creatures closest to the gods and are therefore sacred, such as the white cow in Hinduism or white elephants in Thailand. In Greek mythology, the father of the gods Zeus appeared as a white bull to his beloved Europa. In Christianity, the white lamb represents Jesus Christ and a white dove the Holy Spirit. As a color symbolizing resurrection and redemption, white is the most senior liturgical color in the Catholic Church and is worn by the Pope.

# MOURNING COLOR

Religions that believe in reincarnation or rebirth use white as the color of death and mourning. Hindus, for example, wrap their dead in white cloths before burial. Death is not seen as a final farewell, but as an opportunity for a new beginning. The first Christians also used white as the color of mourning, as it was associated with the resurrection and divine light. During the Middle Ages in particular, women in mourning wore large, white scarves that covered their heads and upper bodies. In Spain, queens and princesses mourned in white until after the 15th century—also to set themselves apart from the public.

As a symbol of virginity and innocence, white is still the most popular color for wedding dresses, especially in western cultures. The tradition began with the nobility. In 1600, Maria de' Medici appeared at the altar in a light, eggshell-colored silk dress. Princess Elizabeth of England followed suit in 1613. After Queen Victoria wore an ivory-colored silk and lace dress at her wedding to Prince Albert of Saxe-Coburg and Gotha in 1840, the trend went mainstream, first across other European royal courts and then, thanks to industrialized production and cheaper prices, among the bourgeoisie. The white wedding dress became popular and affordable and—for one day at least—the dream to be a princess came true.

# WEDDING DRESS

# STATUS SYMBOL

After the end of the French Revolution in the late 18th century, white also became fashionable for everyday clothing. The color signaled higher social status and still connotes refinement and elegance today. A lady who could wear immaculate white clothes made it clear that she had enough servants to do all the household chores. Similarly, a white shirt or a white collar showed that a man did not have to get their shirt dirty at work.

One of the world's most famous buildings is probably the White House in Washington, D.C., the official seat of the incumbent US President. George Washington had it built at 1600 Pennsylvania Avenue on October 13, 1792, the day the American capital was founded. The building was designed by Irish architect James Hoban. The first to move into the White House in 1800 was John Adams, the second President of the United States. At that time, the White House was not known by its current name. It was not until 1901, when Theodore Roosevelt moved in, that it received its famous moniker. The building is painted in a creamy white silicate paint called "Whisper White," produced by the Keimfarben paint company based near Augsburg, Germany.

# WHISPER WHITE

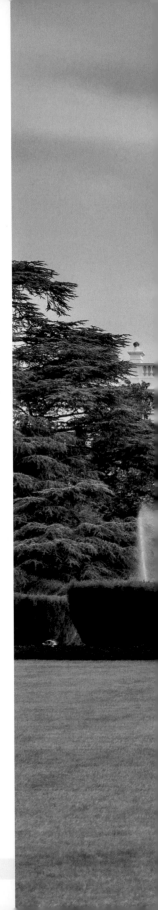

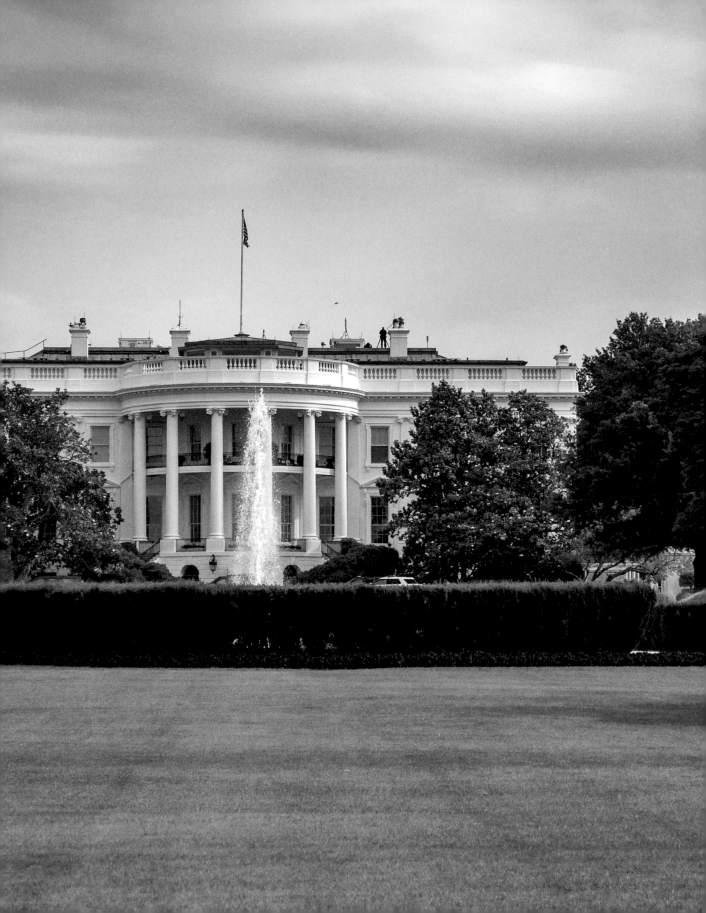

White stands for purity. Processed and refined food products have often had their color removed, or been lightened with the help of a white dye. For a long time, white foods, such as white rice or white bread, were considered to be higher quality and could therefore be sold at a higher price. Today, consumers increasingly value food's natural color. White-colored foods may appear cleaner and finer, but are also perceived as fairly artificial and unhealthy.

# RICE
# FLOUR
# BREAD

One speaks of white as the sum of all colors. Mix the primary colors of red, green, and blue and you'll get white. White light, too, contains a small proportion of all the colors of the rainbow. Contrary to popular belief, white does not embody the physical nothing, but everything. No other color is purer and clearer. Artists have been painting on white surfaces for centuries. White is also the best-selling paper color in the world.

# SUM
# OF ALL
# COLORS

# GHOST
# WHITE

Connected with the pallor of death, white is also a color associated with ghosts and phantoms. A common expression in English is "as pale as a ghost." The Woman in White or White Lady is a familiar figure in ghost stories around the globe. Dressed in white, she is typically the ghost of an ancestor, often appearing to warn of impending death or disaster. The White Lady also makes a reliable appearance in horror movies.

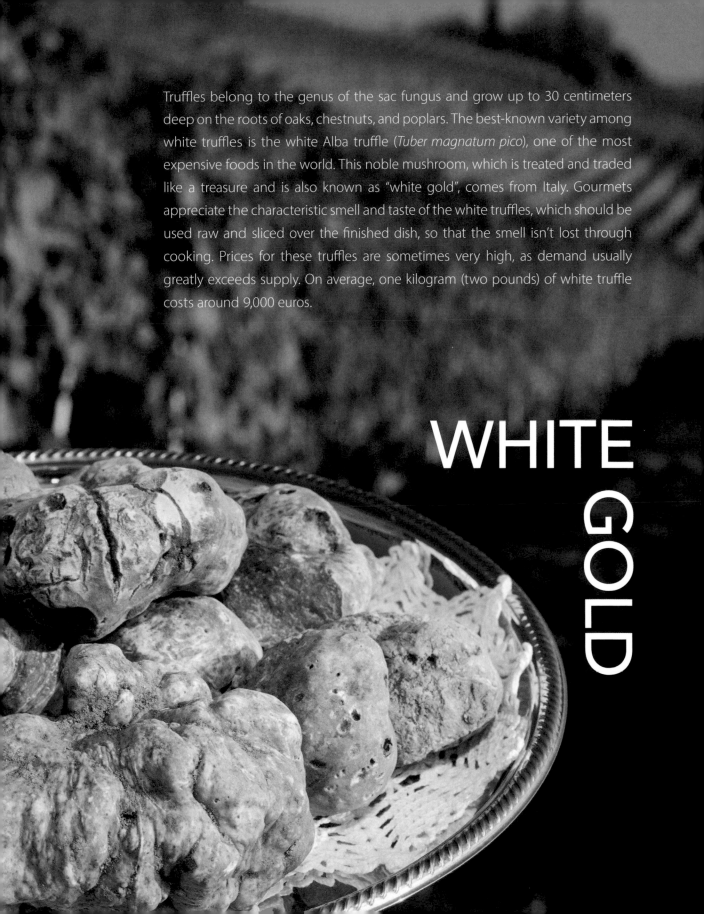

Truffles belong to the genus of the sac fungus and grow up to 30 centimeters deep on the roots of oaks, chestnuts, and poplars. The best-known variety among white truffles is the white Alba truffle (*Tuber magnatum pico*), one of the most expensive foods in the world. This noble mushroom, which is treated and traded like a treasure and is also known as "white gold", comes from Italy. Gourmets appreciate the characteristic smell and taste of the white truffles, which should be used raw and sliced over the finished dish, so that the smell isn't lost through cooking. Prices for these truffles are sometimes very high, as demand usually greatly exceeds supply. On average, one kilogram (two pounds) of white truffle costs around 9,000 euros.

# WHITE GOLD

# YELLOW

# CAVE PAINTING

Yellow has been a favorite color for artists since millennia. Prehistoric cave paintings often feature yellow ochre pigment made from clay, alongside brown, red, and black. At the cave complex in Lascaux, France, there is an image of a horse colored with yellow which is estimated to be 17,300 years old. This makes it one of the oldest known paintings in the world.

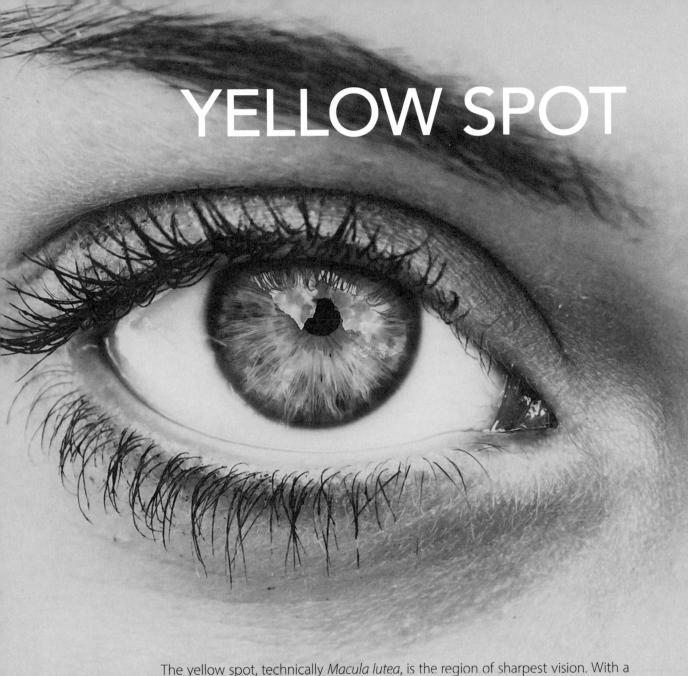

# YELLOW SPOT

The yellow spot, technically *Macula lutea*, is the region of sharpest vision. With a diameter of three to five millimeters in adults, the circular area at the back of the retina has the greatest density of photoreceptor cells. The spot gains its yellow from the pigments lutein and zeaxanthin, but the color is actually so faint that it is barely visible. The visual axis runs directly through the yellow spot; to focus on an object, we unconsciously turn our head so that its reflections fall into the yellow spot area.

# THE EMPEROR'S COLOR

The legendary Huáng Dì, also known as the Yellow Emperor, is considered the founder of Chinese civilization. During his reign, which, according to myth, began around 2697 BC, he is said to have been responsible for numerous inventions and innovations, including the introduction of the Chinese writing system, as well as various sports. For centuries, yellow was the emperor's symbolic color in China and an important symbol of power and status. People were forbidden to wear yellow clothes and could face the death penalty for any violations. In Chinese color theory, yellow stands for tolerance, patience, and wisdom that results from experience. The entrance to the Imperial Palace in Beijing is also known as the Yellow Gate. A Chinese proverb states "yellow clouds bring prosperity." To this day, yellow in Chinese culture symbolizes the country's progress, happiness, and honor.

# YELLOW RIBBON

In many countries, a yellow ribbon stands for solidarity with soldiers and members of the military. The tradition established itself in the United States during the first Gulf War as a symbol of the "Support our Troops" campaign. It is an expression of empathy and represents the desire for a speedy and unharmed return of relatives, friends, and fellow citizens from war zones.

Vincent van Gogh once said of yellow: "Now we have a glorious, tremendous heat here without any wind—just right for me. A sun, a light that, for lack of a better name, I can only call yellow, pale sulfur yellow, pale lemon gold. Oh, yellow is beautiful!" The color appears in almost all of his paintings, and often dominates the entire artwork. For Van Gogh, yellow was a warm, radiant color that gave his paintings a touch of sunshine. He was so fascinated with the color that he allegedly tried to eat it— though whether this is fact, or another shade in the artist's ongoing mythology, remains unknown.

# VINCENT VAN GOGH

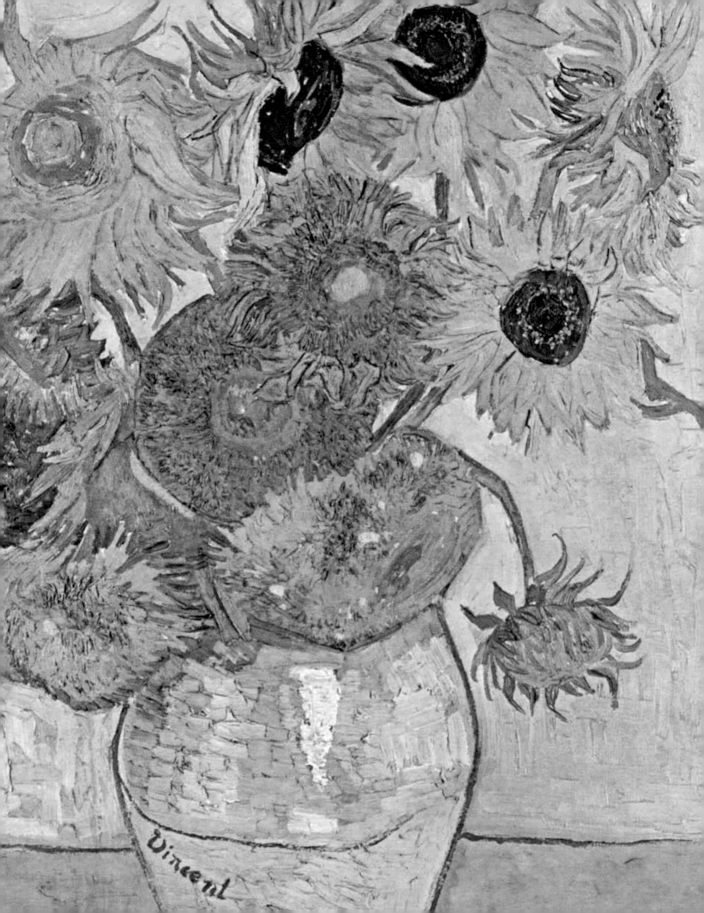

# YELLOW STAR

Yellow also has a dark history of marking perceived outsiders. In Christian tradition, yellow connoted saintly halos and the golden key to the Kingdom of Heaven, but also came to be associated with the treacherous Judas Iscariot, typically painted in a yellow robe. During the Spanish Inquisition, those accused of heresy who refused to disavow their views were made to wear a yellow cape. In the 20th century, Jews in Nazi-occupied Europe were forced to wear a yellow star.

# WARNING

Yellow is the lightest of all basic colors and therefore has an optimal long-range effect. In Europe, yellow has warned of dangers, epidemics, and diseases since the Middle Ages. If the plague broke out in a city, a yellow flag hung on the city wall, recognizable to everyone from afar. The yellow flag is still hoisted in international shipping today, but if it stands alone it means that everyone on board is healthy. If it is used in combination with other flags or the first substitute flag, it indicates suspected disease. The combination of yellow and black is used worldwide as a warning signal and for hazard alerts in road traffic management. The light-dark contrast ensures easy legibility and is conspicuous and memorable at the same time. The yellow-black combination is also a warning color in the animal kingdom and signals danger and poison, for example with hornets and wasps.

# SAFFRON

Saffron is one of the oldest, most famous and most expensive dyes of all time. The name is derived from the Arabic word *zafaran* (color). Saffron threads are extracted from the stigmas of the saffron crocus flower (*Crocus sativus*). Each flower only produces three stigmas, so to get one kilogram (two pounds) of saffron, 150,000 to 200,000 flowers have to be laboriously picked by hand. A single worker can only manage 60 to 80 grams a day. In addition, the saffron plant only flowers once a year, for a few weeks in autumn. Dried saffron threads can therefore cost several thousand euros per kilogram.

# YELLOW PRESS

The English term "Yellow Press" probably dates back to the first modern comic, *The Yellow Kid*. From 1895, the character Mickey Dugan, barefoot and dressed in a yellow nightshirt, regularly appeared in the *New York World* and from 1896 in a competing newspaper. Instead of speech bubbles, the comic text was printed on Mickey's gown. With street-style vocabulary and haphazard spelling, the character was a hit among the American working class. Longer and longer stories ensued. The two newspapers which ran *The Yellow Kid* became known as the "yellow kid papers", later contracted to "yellow journalism" or "yellow press", and signaling to profit-driven sensationalism and low-brow content. Nowadays, "Yellow Press" is mostly associated with tabloid newspapers and gossip magazines.

No other cosmopolitan city is as identified with its taxis as New York. The yellow taxi is one of the hallmarks of the city that never sleeps. In fact, the first 65 cars imported from Paris by the New York Taxicab Company in 1907 had a red and green paint job, but this soon changed when increasing competition demanded maximum visibility. Each taxi company chose their own "signal color". In 1915, John D. Hertz founded the Yellow Cab Company in Chicago after a university study found that yellow was the most visible color—even over great distances. From an original fleet of 40, the company grew and expanded into Kansas City, Philadelphia, and New York—where taxis have been yellow since the 1960s. Today, some 13,000 yellow cabs cruise through Manhattan.

YELLOW CAB

# ORANGE

ROYAL HOUSE OF ORANGE
CHEAP PLASTIC STUFF
70S DESIGN
HENNA
BUDDHISM
WATCH OUT!
OUT OF NECESSITY
MONARCH BUTTERFLY
ORANGE FRUIT
APPETIZER

# ROYAL HOUSE OF ORANGE

Orange is the national color of the Netherlands and of the Dutch royal house of Orange-Nassau. The Orange dynasty did not originate in the Netherlands, but in the Provençal city of Orange in France. In Dutch culture, orange is considered the color of freedom. On the national holiday of King's Day or Queen's Day, which traditionally takes place on the birthday of the current king or queen, the country is bedecked with orange flags and many Dutch people dress top to toe in orange.

Orange is often associated with plastic goods. Manufacturers rely on the bright, conspicuous, and cheerful color to catch attention. Orange is less likely to be associated with high-quality or exclusive products; it exudes instead a certain garishness and artificiality. In the automotive industry, cars are rarely produced in orange. Although they're conspicuous on the road, they look neither classy nor elegant.

# CHEAP PLASTIC STUFF

# 70s DESIGN

Orange was the in color of the 1970s, capturing the energy of a young generation—powerful, daring, and creative. Carpets, upholstery, dishes, lamps, wallpaper—everything was available in orange. In combination with a variety of other colors, living rooms quickly turned into a chromatic horror show. As more and more cheap orange plastics came onto the market, the color gradually lost its allure. At least in terms of interior design, people moved on to other entries in the color palette.

# HENNA

Henna is a red-yellow dye obtained from the dried and powdered leaves of the henna bush. In India and other countries, women decorate their feet and palms, hair, and fingernails with henna at traditional ceremonies and events such as weddings. The artistic and culturally significant patterns are also called "Mehndi." In *The Meaning of Colors*, Franz Immoos writes: "The flower of the henna bush is called the 'flower of paradise.' The yellow-orange, bewitchingly fragrant blossom is part of Buddhist ceremonies like incense is part of Catholic worship."

# BUDDHISM

In Buddhism, orange represents the highest level of human knowledge. The combination of yellow (perfection) and red (luck) also symbolizes maturity and wisdom. Buddhist robes come in different colors, depending on the region and school of Buddhist practice. They can be yellow, orange, or red—sometimes a combination—or brown and gray.

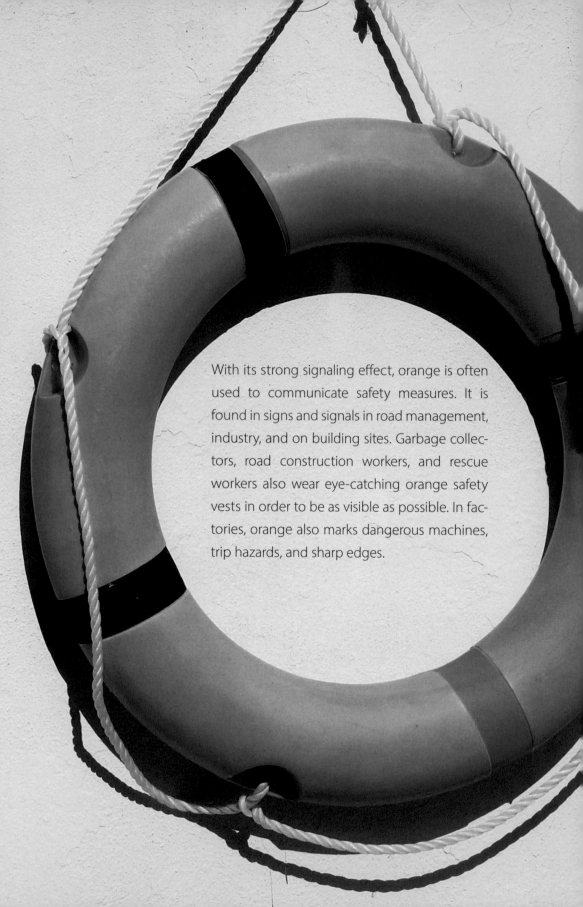

# WATCH OUT!

With its strong signaling effect, orange is often used to communicate safety measures. It is found in signs and signals in road management, industry, and on building sites. Garbage collectors, road construction workers, and rescue workers also wear eye-catching orange safety vests in order to be as visible as possible. In factories, orange also marks dangerous machines, trip hazards, and sharp edges.

# OUT
# OF
# NECESSITY

The Parisian luxury brand Hermès, founded by Thierry Hermès in 1837, has long used a warm shade of orange for its packaging. But the brand color scheme wasn't there from the start. During the Second World War, stocks of the original packaging—initially cream with a golden border, then beige with brown decoration—ran out. The company's cardboard supplier fell back on what was available and it happened to be orange. Out of necessity, the color became Hermès' trademark.

# MONARCH BUTTERFLY

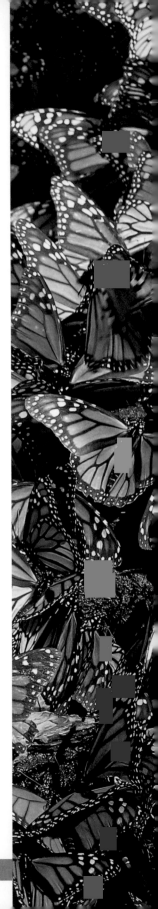

Every autumn, in the high plateau of the Sierra Nevada, a natural phenomenon occurs. In just two months, millions of orange-black monarch butterflies fly up to 4,500 kilometers (2,800 miles) to take up their winter quarters. Their destination is the Oyamel pine forests in the highlands of the Mexican state of Michoacán. The butterflies cover up to 300 kilometers (186 miles) a day and fly in groups of a few hundred. Upon arrival, they hang in dense clusters on branches to protect themselves from low temperatures and wind. But the record-breaking North American flyers are increasingly threatened by the loss of their habitat and destruction of their food sources. The number of Monarchs that find their way to Mexico is steadily decreasing.

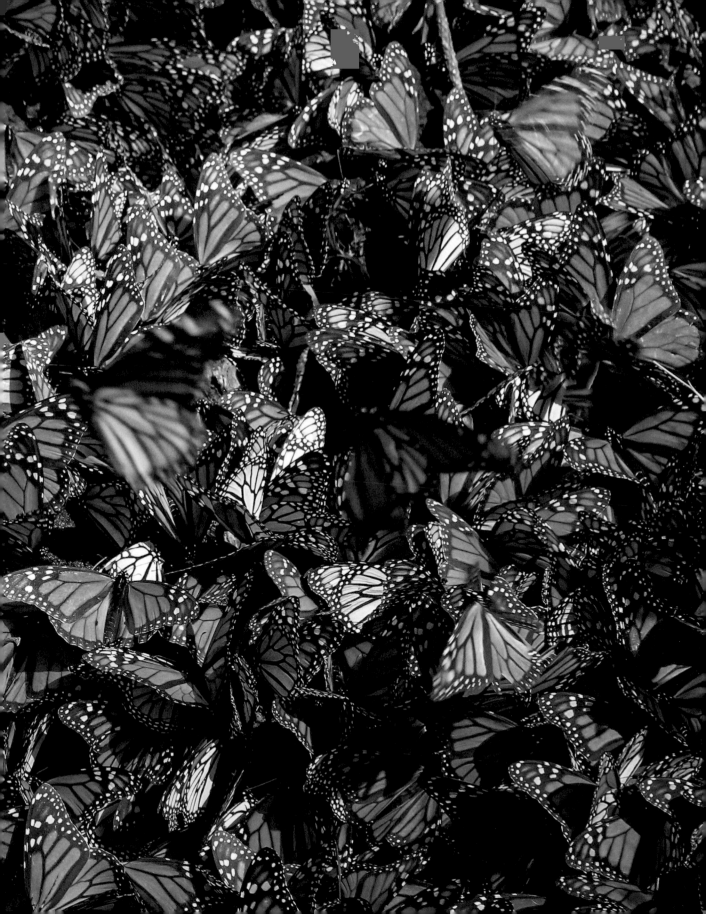

The color orange takes its name from the citrus fruit. The fruit was not widely distributed in Europe until the 15<sup>th</sup> century, so the term orange—derived from the Arabic *nārandsch*—did not exist before then. Corresponding shades were instead referred to as red-yellow or yellow-red. Today, the name of the fruit and the name of the color are identical in almost all languages.

# ORANGE FRUIT

# APPETIZER

Research shows that warm colors such as orange stimulate the appetite; they ensure a pleasant and friendly atmosphere, creating coziness, conviviality, warmth, and good energy. For this reason, orange is one of the most popular colors in gastronomy and is an ideal tone for the dining room or kitchen, increasing enjoyment of food and drinks.

# RED

# RED BLIND

A bee has two large compound eyes that consist of approximately 6,000 individual lenses. Through them, she perceives her environment and objects in a grid-like, pixel image. Bees have no receptors for red light; they are red-blind and see red flowers as a dark spot. A red-covered poppy flower field, for example, is completely black from a bee's point of view. They prefer the colors blue and yellow. Bees also have the unique ability to see ultraviolet light and therefore orient themselves to the position of the sun.

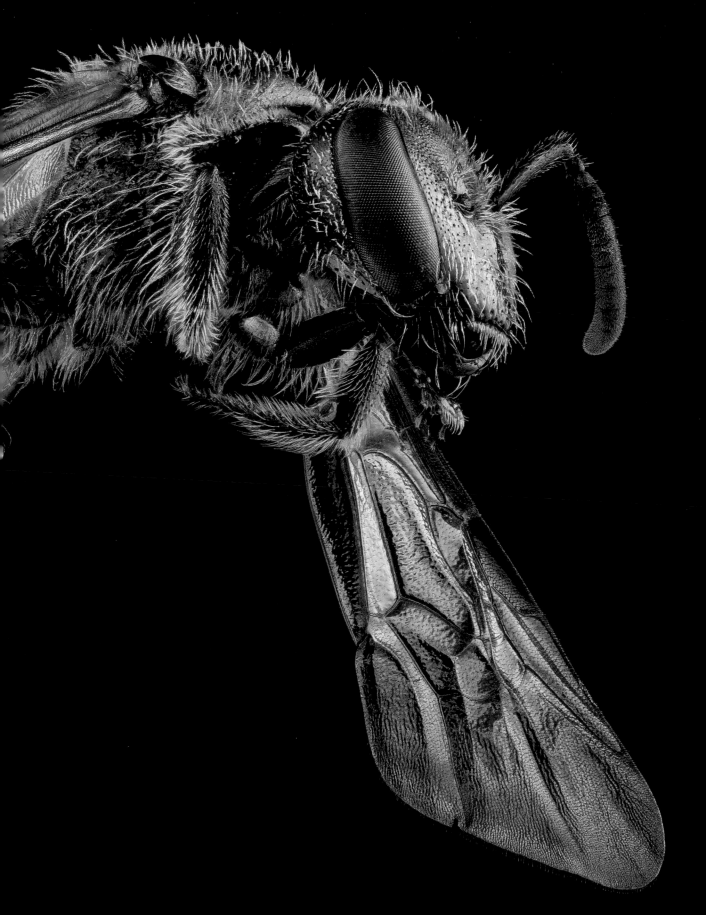

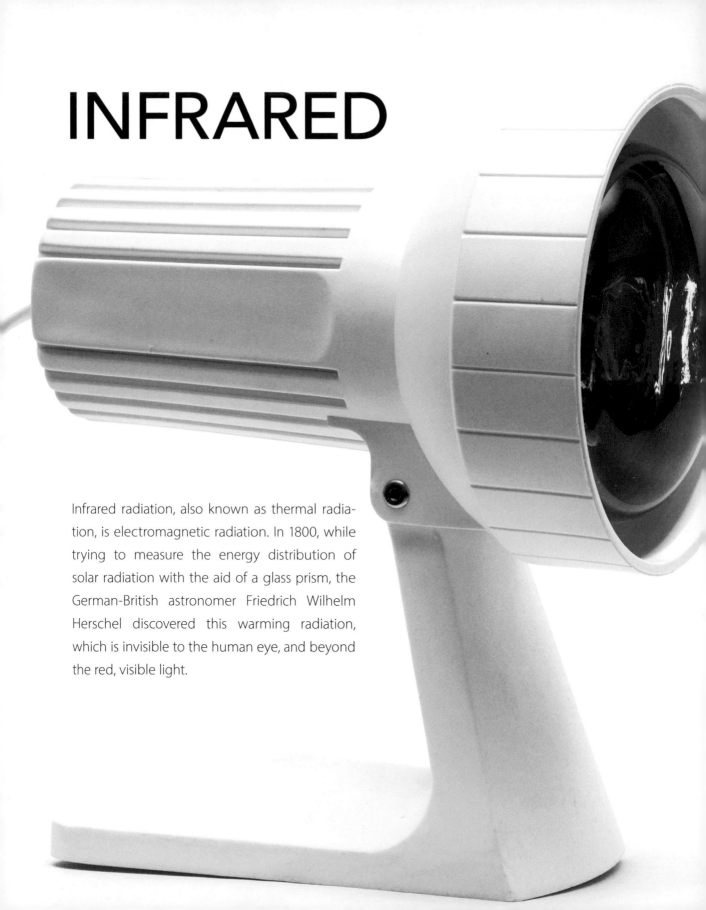

# INFRARED

Infrared radiation, also known as thermal radiation, is electromagnetic radiation. In 1800, while trying to measure the energy distribution of solar radiation with the aid of a glass prism, the German-British astronomer Friedrich Wilhelm Herschel discovered this warming radiation, which is invisible to the human eye, and beyond the red, visible light.

# METABOLISM

The color red is the most warm, dynamic, and aggressive of all colors. It has an activating and invigorating effect, but also creates restlessness. Red has a stimulating effect on the circulatory and immune systems, accelerating the breath and promoting blood circulation. In *Red: Instructions to Read a Color*, Alexander Theroux writes that the human metabolism increases by 13.4 percent just by seeing red.

# THE
# RED
# RIVER

*Tinto* is the Spanish word for red (and dyed) and the Río Tinto in Spain stands by its name. The 100-kilometer (62-mile) long river, rising in the Sierra Morena mountains in Andalusia and flowing into the Atlantic Ocean near Huelva, glows various shades of red. Despite its otherworldly appearance, there are very earthly reasons for the color. The river runs through an area rich in sulfide ore deposits. When the metals in these buried deposits are exposed to air and water, they produce acidic runoff that flows into the river and turns it red. Thousands of years of mining in the region has intensified the process. Swimming in the Río Tinto is strictly off limits; the high acid content means only microorganisms can survive in the water.

The most Earth-like planet in our Solar System is made up of metal and rock. It's half the size of Earth with volcanoes larger than Mount Everest. You shouldn't go for a stroll without a space suit; below freezing temperatures, low air pressure, and UV radiation of the sun—without a protective ozone layer—make the environment hostile to life. The planet's striking red appearance fascinated mankind early on. The association with blood probably inspired the ancient Romans to name it after the god of war, Mars. The color comes from a fine layer of red dust covering the planet, although since it is largely made of basalt, the dust should logically be black. The common assumption was that the dust was rusted iron. Later, scientists at the Mars Simulation Laboratory in Aarhus, Denmark, theorized that it might come from ongoing friction of quartz sand and magnetite—an iron ore found in basalt—on Mars' surface. More recent discoveries of liquid as well as frozen water on Mars has put the rust theory back on the table.

# THE RED PLANET

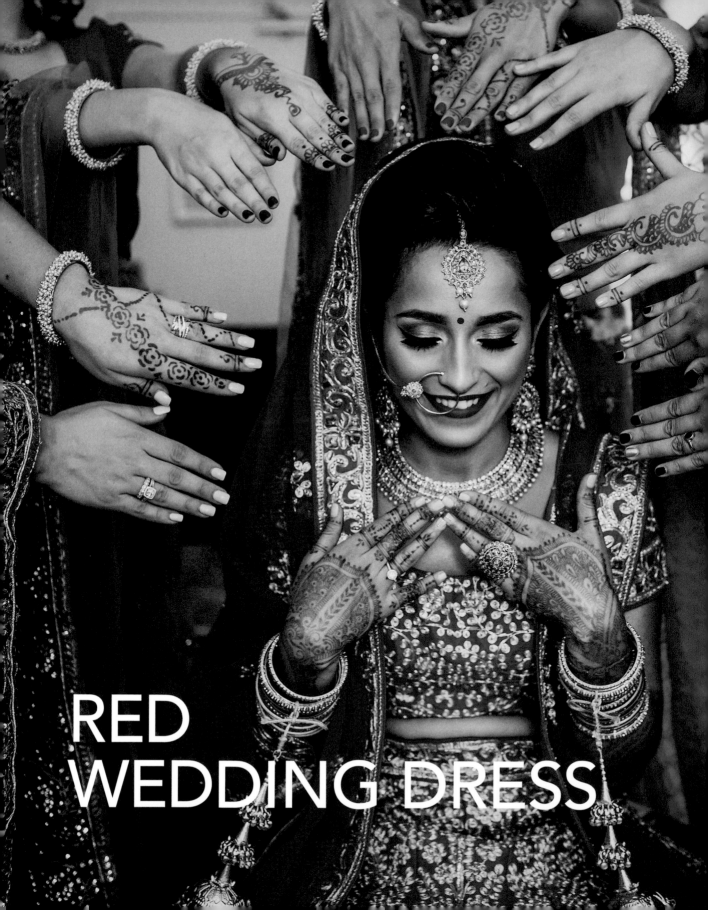

RED
WEDDING DRESS

# PARASITE

The cochineal is a parasite insect native to the tropical and subtropical Americas. The insect lives on cacti, feeding on plant moisture and nutrients, and produces a red acid that deters predators—and colors lipsticks. Since the 15th century, cochineal have been collected, dried, and pulverized to create scarlet, crimson, and orange tints. It remains prevalent in the fashion and cosmetics industries, as well as in food production as a coloring agent. There is now a synthetically-produced variant, cochineal red A (E 124), but fears over artificial additives have renewed popularity of the original insect dye.

# PAINT

The color red still plays a huge role in wedding fashion in many cultures, although as Western influence increases, the white wedding dress is becoming increasingly popular. In India and China, for example, the *sari*, *qipao* or *cheongsam* in red are an inherent part of a traditional wedding ceremony. The color symbolizes love, luck, prosperity, and fertility.

# ROSES AND THE RED LIGHT DISTRICT

Described by the Greek poet Sappho as the "Queen of Flowers," the rose was revered in Ancient Greece. The flower's origins go back even further; fossil finds indicate that wild roses existed as early as 25 million years ago. But it was Greek mythology that ordained the red rose as a symbol of love. Hurrying through the forest to her dying lover Adonis, Aphrodite, the Greek goddess of love, beauty, and sensual desire, pricked herself on the thorns of a white rose, symbolizing the purity of love, and colored the flowers red with her blood. So the (red) rose not only stands for love, but also for pain: "No rose without thorns." Associated with love, passion, and desire, red also came to illuminate brothels and sex-oriented businesses, as in the Red Light District.

# THE RED SQUARE

The most famous square in Moscow has been a UNESCO World Heritage Site since 1990. Originally a trading center, the Red Square (in Russian *krasnaja ploščad*) is now the location of numerous important buildings for the country's politics, culture, and economy. In addition to the Kremlin, the Lenin Museum, and St. Basil's Cathedral, the square also hosts the most famous department store in Russia, GUM. Very few people know that the Red Square is actually also called the "Beautiful Square." The adjective *krasnaja* can mean both "red" and "beautiful," but over the years the second meaning has been lost and only red is applied today.

# FALUN RED

Red houses have been a mainstay of the Swedish landscape for centuries. Since the 1700s, a red pigment obtained as a by-product from copper mining was used to coat wooden homes. Known as Falun red or Swedish red, the color was reminiscent of the brick buildings of wealthy Central Europeans. It is named after the Swedish town of Falun, famous for its copper mine, which was shut down in 1992 after almost 400 years of operation. Falun red is still used as a traditional color for wooden buildings, especially in rural areas.

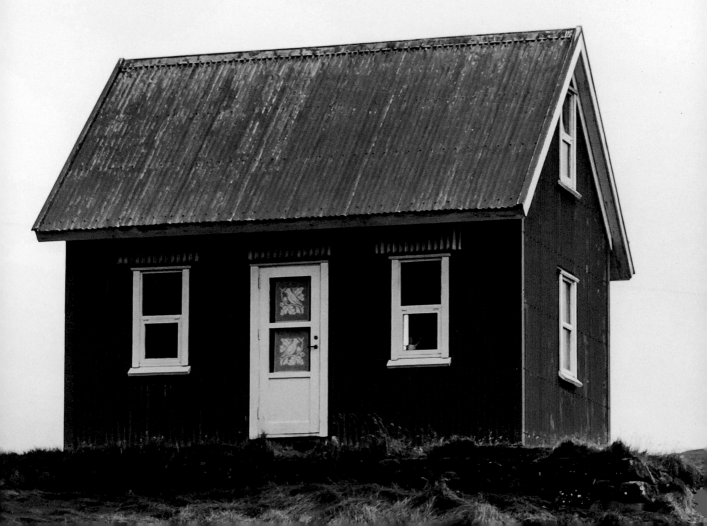

# PINK

# PINK
# TASTES
# SWEET

Since particular colors arouse particular associations, they are strategically used in advertising and product development to appeal to the senses. At the sight of a pink dish, our taste buds prepare for a sugary flavor—so it is not without reason that the shade is often used for sweets, candy floss, and ice cream. The association has even made it into our color vocabulary—candy pink. Since pink tones also symbolize lightness and innocence, pink-colored confectionary or packaging encourages quick and spontaneous consumption.

When a ray of sunlight travels through the atmosphere, some of the colors are scattered out by air molecules and airborne particles. Colors with a shorter wavelength, such as blue and green, scatter more strongly. At sunrise and sunset, when the sky is low and sunlight has the longest path to the eye, the blue and green components are removed almost completely, leaving only the longer wavelengths of orange, red, and pink light. It's this effect, known as Rayleigh scattering, that gives the sky its pinkish glow at sundown and dawn. An old weather saying associates a pink sunset with fair weather the next day, while a pink sunrise threatens rain and wind: "Pink sky at night, shepherd's delight. / Pink sky in the morning, shepherd's warning."

# PINK SKY

# PINK RIBBON

Since the early 1990s, a pink ribbon has been an international symbol of breast cancer awareness and solidarity. As with ribbons in other colors (awareness ribbons), the symbol is used to strengthen public discourse and support. The Susan G. Komen Breast Cancer Foundation, one of the world's largest breast cancer foundations, first distributed the pink ribbon to participants in a charity run in the fall of 1991. Since 1985, October has traditionally been marked as breast cancer awareness month and is accompanied by numerous events, campaigns, and projects.

# THE LITTLE RED

Today it's hard to imagine that pink was not always a so-called girl's color. But for a long time red traditionally stood for masculinity and pink was the "little red" reserved for very young men. In the 1920s, boys were still the main target group for textile companies selling pink clothing. As the *Ladies' Home Journal* reported in 1918: "The generally accepted rule is pink for boys and blue for girls. The reason for this is that pink is a more determined, stronger color and therefore suits boys better, while blue, which is more delicate and graceful, looks prettier on girls." Centuries earlier, Christian art shows the same pattern: Baby Jesus wears pink, the Virgin Mary wears blue. Pink was also a trend color for noblemen in Rococo and Elizabethan England. It was only with the increased mass production of blue workwear that blue became "masculinized."

# FLAMINGOS

Flamingos are not born pink. The young birds have white feathers with gray spots, and can take years to acquire their pink plumage. The coloring is caused by the birds' preferred food and a corresponding genetic predisposition. The flamingo feeds mainly on algae and small water crabs, which contain the color pigment carotenoid, also found in carrots. Just as babies' skin turns slightly orange when they eat a lot of carrot puree, so the natural dye of the crabs is deposited in the flamingo feathers and turns them pink. The color also influences reproduction; female flamingos prefer males with particularly bright pink feathers. In zoos, where the menu rarely consists of crustaceans, flamingo food is mixed with the likes of carrot juice in order to achieve the same color process. Unlike flamingo meat, which was eaten in some regions until the 20th century, flamingo feathers have never been particularly sought after, not least because they lose their distinctive color after plucking.

# WONDER
# OF THE
# WORLD

The eighth wonder of the world is also said to have been pink. Up until the late 19th century, New Zealand's "white and pink terraces" attracted visitors from all over the world. The wonder was the result of minerals from hot thermal water springs, which came to the surface via geysers, and were deposited in a step-like formation on a slope. In 1886, the natural spectacle was completely buried by a volcanic eruption of Mount Tarawera. The eruption tore a 100-meter-deep (330-feet-deep) crater into the terrain, which filled with water and forms what is now Lake Rotomahana. According to a 2017 research thesis, the colored terraces could still be under the lake shore.

# SEDATIVE PINK

Can pink really reduce aggression? American psychologist Alexander G. Schauss explored this question in 1979 with two prison experiments. A cell for the initial reception of prisoners was painted completely in pink, in a shade later referred to as Baker-Miller Pink. Schauss' results suggested that the pink had a relaxing effect, reducing the prisoners' heartbeat and blood pressure, and thus reducing violent behavior. This relaxed state persisted for some time—even after the prisoner was transferred to a regular cell. Since then, a second, somewhat cooler, tone of pink is often used in prisons—Cool Down Pink, developed by the Swiss color psychologist Daniela Späth. Some psychiatric clinics also use this tone for their relaxation rooms.

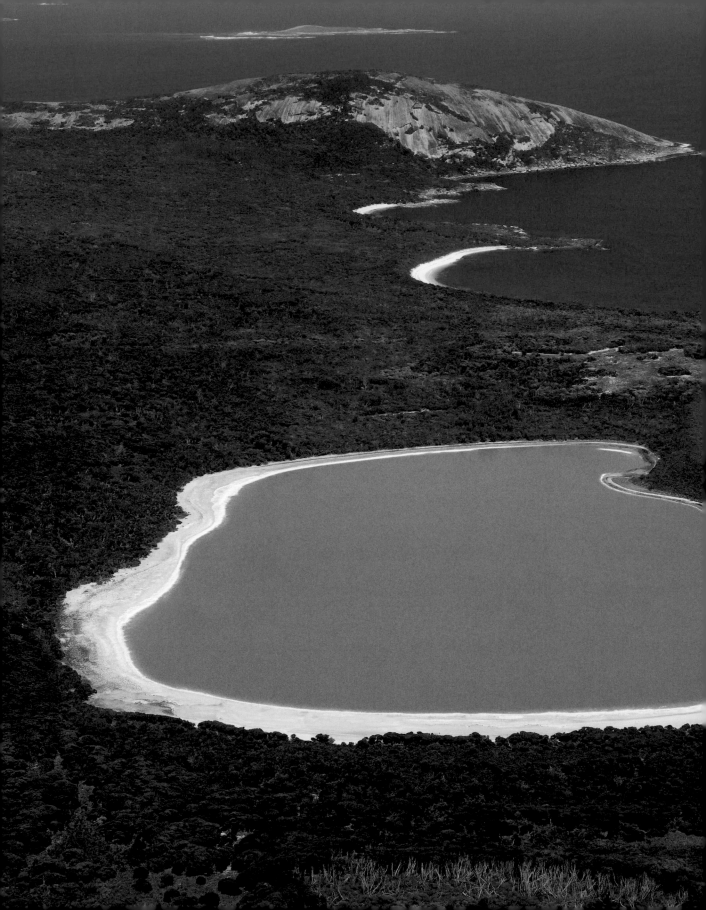

# THE PINK LAKE

You don't have to look through rose-tinted glasses to see Lake Hillier in its pink glory. The salt lake in Middle Island, on the southern coast of Western Australia, glows so pink that it can even be seen from space. Situated on the so-called Recherche Archipelago, the lake is separated from the sea by just a narrow strip of dunes. It was first discovered in 1802, when an expedition of the British explorer Matthew Flinders climbed the island's highest peak and spotted the pink pool of water. In contrast to other salt lakes, which only have characteristic colors under certain weather or light conditions, Lake Hillier retains its color even when the water is removed. The origin of the pink is yet to be completely resolved, but it's believed to be the result of special bacteria and algae. You cannot see the phenomenon close up; all the islands of the archipelago are under strict environmental protection. There are, however, regular sightseeing flights over the lake from the mainland.

# PINK PILLS

Pharmaceutical companies color drugs for better differentiation and recognition, but the color of pills also has an impact on patient acceptance. Thus, drug manufacturers use common knowledge from color psychology, deploying certain colors to suggest certain effects. For example, in a 1972 study by Blackwell, Bloomfield & Buncher, it was found that blue drugs are perceived as calming and pink pills as stimulating. Antidepressants are therefore often colored red, while laxatives tend to be brown and stomach remedies green. Pills that appeal to women, such as birth control pills and drugs supposed to boost the libido, are often pink.

# PETAL PINK

Pink is one of the most common colors among flowers, serving to attract the insects and birds necessary for pollination, and to deter predators. Roses, peonies, tulips, and dahlia are often pink, while in Japan the bountiful pink blossom of the cherry tree makes pink the color most readily associated with springtime. As soon as the cherry trees come into bloom, Japanese people gather at parks, shrines, and temples to hold flower-viewing parties. Known as hanami, these seasonal festivals date back to the 3rd century AD.

# PURPLE

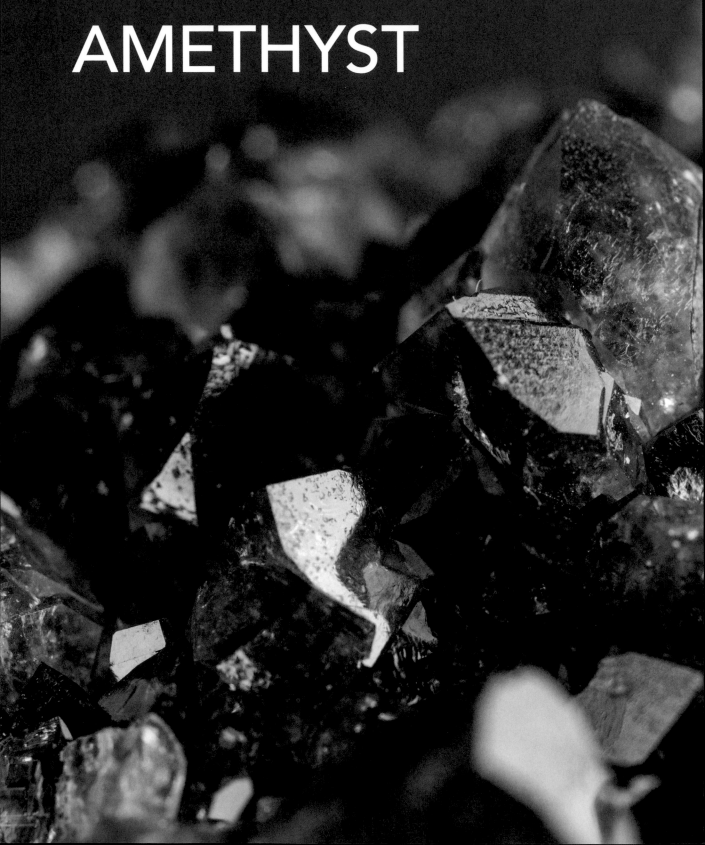

# AMETHYST

Amethyst is a variety of quartz, a hard crystallized mineral. Amethyst colors range from light lilac tones to deep purple and violet-red. The color of each amethyst determines its price; the deeper the shade, the more expensive it is. Color purity also plays a role; in addition to purple, amethysts can often contain blue, pink, or gray tones. One of the most expensive amethyst variants is the dark purple Deep Russian, originally from Siberia. Associated with power and nobility, the amethyst has long been one of the most popular gemstones, prized by high-ranking dignitaries. Catholic bishops still wear amethyst rings today. Etymologically, the name amethyst comes from the Greek word *amethystos*, meaning "to avoid drunkenness." Popular wisdom had it that the amethyst protected against the intoxicating effects of wine. Thus, wine consumed from an amethyst goblet should not make you drunk. This theory is probably explained by a color association: watered-down wine, with its reduced alcohol content and diminished effects of intoxication, has an amethyst-like color.

# THE SHADE OF SNAILS

Purple has always been considered an extravagant color. Even today, real purple is one of the most expensive dyes (approx. € 2,500 per gram) and used only in special circumstances, for example in the restoration of antique purple clothes. But purple's origins are less glamorous. Original purple dye was obtained from the purple sea snail, which lives in the Mediterranean and belongs to the family of spiked snails. Archaeological finds suggest that purple extraction probably began as early as the 19th century BC when the Phoenicians discovered the coloring effect and set up production facilities in Tyre, in present-day Lebanon. Even the name Phoenician points to their color discovery; the ancient Greek equivalent *phoinikes* is based on the Greek *phoínix*, meaning "purple red."

To produce the dye was a demanding process. First, there was the extraction of the snail's hypobrachial mucus gland—a notoriously foul-smelling operation. The gland was then placed in salt for several days before being boiled in water. Initially, the dye was still unsuitable because it did not adhere to fabric. Only after a few further days of fermentation did a water-soluble dye develop, which first colored fabrics yellow-green, before finally producing the desired purple through oxidation. It took about 12,000 snails to make just one gram (0.04 ounces) of pure purple.

# FEMINISM

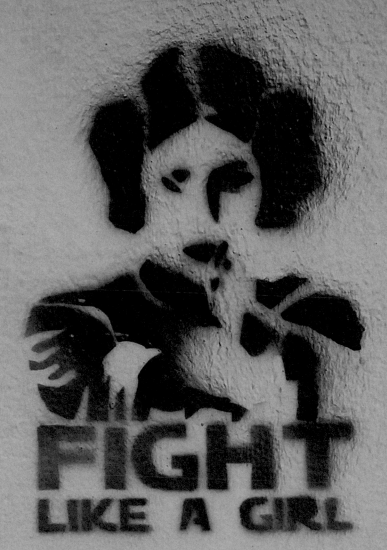

In the 1970s, the color purple became the color of the women's movement. Purple dungarees, loosely skimming the chest and hips and nodding to proletarian labor, became a staple of the feminist wardrobe. Earlier, English suffragettes had campaigned for women's voting rights with purple as one of their three campaign colors (the others being white and green). During the years of the Weimar Republic in Germany, the "Purple Song" had also been a cult gay anthem. Why purple? One possible explanation is that purple is a mixture of red and blue, two colors ascribed opposing, often gendered, attributes. As a mixture of the two, purple symbolized self-realization, liberation, and emancipation. In 1982, *The Color Purple*, by American writer and Pulitzer Prize winner Alice Walker combines themes of freedom: the epistolary novel addresses lesbian love, patriarchal violence, and discrimination against Afro-American women.

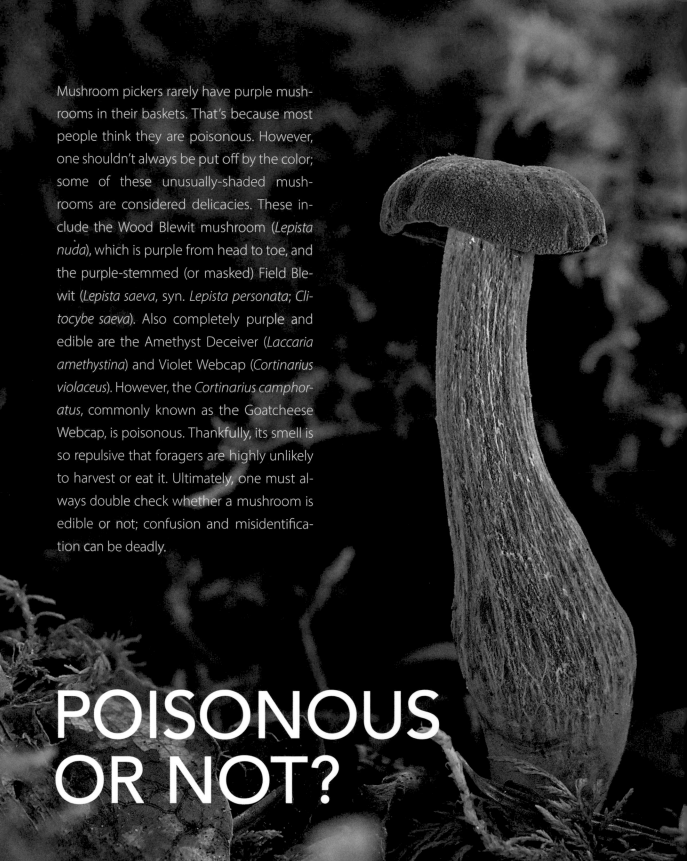

Mushroom pickers rarely have purple mushrooms in their baskets. That's because most people think they are poisonous. However, one shouldn't always be put off by the color; some of these unusually-shaded mushrooms are considered delicacies. These include the Wood Blewit mushroom (*Lepista nuda*), which is purple from head to toe, and the purple-stemmed (or masked) Field Blewit (*Lepista saeva*, syn. *Lepista personata*; *Clitocybe saeva*). Also completely purple and edible are the Amethyst Deceiver (*Laccaria amethystina*) and Violet Webcap (*Cortinarius violaceus*). However, the *Cortinarius camphoratus*, commonly known as the Goatcheese Webcap, is poisonous. Thankfully, its smell is so repulsive that foragers are highly unlikely to harvest or eat it. Ultimately, one must always double check whether a mushroom is edible or not; confusion and misidentification can be deadly.

# POISONOUS OR NOT?

# ROYALTY

Because of the exorbitant costs of early dye production, purple is the color most deeply associated with royalty and power. Roman emperors wore Tyrian purple togas. In the Byzantine Empire, rulers donned flowing purple robes and signed their edicts in purple ink. Queen Elizabeth I of England forbid anyone but her closest relatives to wear purple clothes. Today, purple is a much more accessible shade, but the British Royal Family and other European royals still wear the color for special occasions and ceremonies.

# MAGIC

Even in the world of costumes and masquerade—be it carnival or Mardi Gras—purple is often worn to embody magic, witches, wizards, and fairies. Combining the physical (red) with the spiritual (blue), the color has long been associated with ritual acts and mystery. Sometimes, the sky turns purple at dusk or dawn, symbolizing the transition from the earthly to the unknown realm of spirits, ghosts, and demons. Likewise for shamans, purple is a bridge from this world to eternity.

# MAUVE

What do penicillin, x-rays, teflon and the color mauve have in common? All are accidental discoveries of science. In 1856, 18-year-old chemistry student William Henry Perkin was commissioned by his professor at the Royal College of Chemistry in London to develop a synthetic active ingredient against malaria. Previously, anti-malarial drugs were made from quinine, an expensive organic ingredient. Perkin's challenge was to derive a comparable drug from the aniline in coal tar, a by-product of gas lantern manufacture. Perkin was unable to develop the chemical compound for an effective treatment, but he did discover purple-colored residues in his glass vessels, which could be dissolved in water and alcohol and had a coloring effect. He initially called the delicate new dye "Tyrian purple," based on the much sought-after antique shade, but soon renamed it Mauve or Mauvein, the French name for wild mallow, which has flowers of the same color. By pure chance, Perkin developed a new trend color. He also founded the UK's first tar paint factory.

# PROVENCE

Lavender grows across Europe, northern and eastern Africa, southwest Asia and southeast India—but nowhere is more associated with the fragrant purple plant than the southern French region of Provence. The area's world-famous lavender fields start to bloom in June, peaking in mid-July. Some of the best-known—and photographed—fields are in the Valensole Plateau and Luberon Valley. Provençal cuisine has also come to incorporate lavender; the flower flavors oils, honey, and sorbets. Lavender-scented soap is also a classic Provençal souvenir.

Purple's best-known shades both have floral origins. "Lilac" comes from the Arabic word *lilak*, which denotes the lilac flower or a similar color, and which established itself in Europe through the French *lilas*. "Violet" also comes from French, with *violette* signifying the violet flower, the diminutive of the Latin *viola*, to which genus the plant belongs. Both terms were established as color names in German around the 18th century. Before that, lilac and violent were more likely to be termed red-blue or vice versa, as in "red cabbage" and "blue cabbage."

LILAC AND VIOLET

# ULTRAVIOLET

Ultraviolet light was first discovered in 1801 by German natural scientist Johann Wilhelm Ritter by blackening silver salts (later used in analog photography) with sunlight. Ritter noticed that the blackening was greatest beyond the visible violet edge of the light fan, which he created using a prism. This phenomenon—known as UV light, ultraviolet radiation, or UV radiation—is visually imperceptible to humans, but has clearly noticeable effects. Both UV-A and UV-B influence our bodily functions, helping to build and maintain healthy bones and skin, and impacting our psychological disposition. The main source of ultraviolet light is the sun. Artificial UV radiation is used to treat skin diseases.

# BLUE

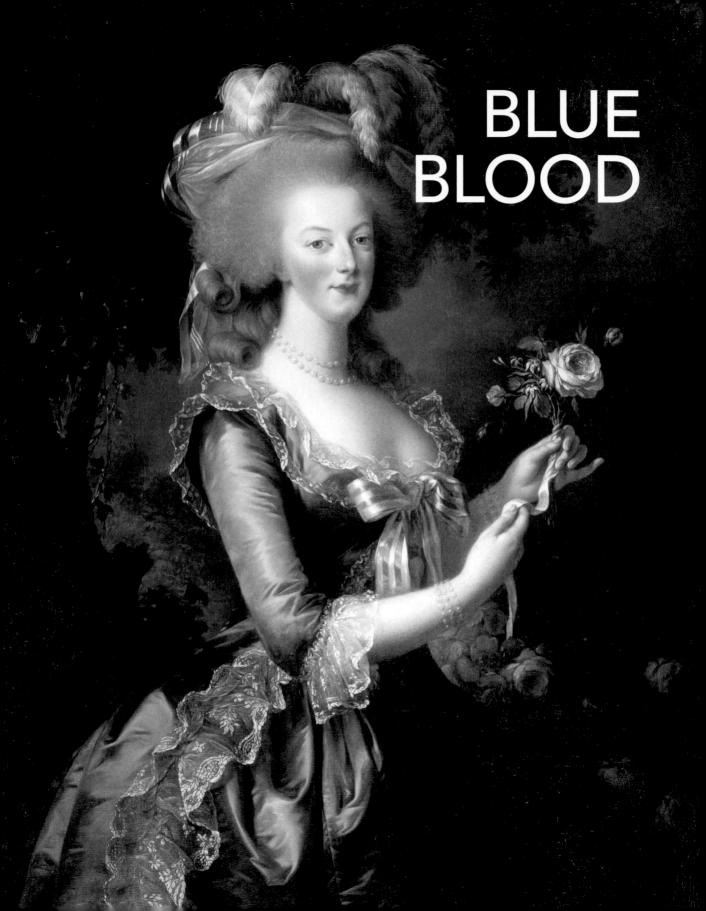

BLUE
BLOOD

Many western cultures have a history of elevating pale skin as aspirational and noble. In aristocratic circles of the Middle Ages, an elegant pallor was the predominant beauty ideal, firmly associated with the upper class, because only the rich and powerful were not forced to work outdoors in the sun. The term "blue blood" originally comes from the Spanish *sangra azul*, which Spaniards used to refer to their upper class, who were mainly descended from northern European Visigoths. For native Iberians, whose skin is darker, the veins under this lighter skin seemed to course with blue blood. The idiom soon became synonymous with aristocratic lineage.

# PORCELAIN

From Delft to Meissen, Staffordshire to Saint Petersburg, white and blue is one of the most quintessential color schemes for porcelain. The tradition originated in 9th-century China, where artisans began using cobalt blue dye to create intricate blue and white patterns. Plants and vases were shaped, dried, and then decorated with a fine paintbrush before being glazed and fired. In the 14th century, Chinese porcelain was exported in vast quantities to Europe, inspiring a whole new trend of *Chinoiserie*. European courts tried for centuries to master the blue-and-white technique, but only succeeded in the 18th century, when a missionary brought the secret back from China.

# ULTRA MARINE

In Latin, *ultramarine* means "beyond the sea" and indeed, ultramarine blue had a long journey to Europe. The stone from which the color was extracted, lapis lazuli, came from the Afghan town of Sar-e Sang, where mines were already in operation 6,000 years ago. The ancient Egyptians first transported lapis to Europe as a precious gemstone, but it was only in the Middle Ages that a process was developed to extract the stone's pigment, also known as *Fra Angelico Blue*. The process is extremely complex—around a 50-stage operation—and made the color all the more valuable. Its good coverage and resistance to heat and light were also prized. From the late Middle Ages through to the Renaissance, ultramarine blue developed into the most popular color in church painting, most particularly for the robes of the Virgin Mary. Because of its high costs, the French Société d'Encouragement pour l'Industrie Nationale awarded a prize in 1824 for the development of an inexpensive equivalent. In 1828, the Frenchman Jean-Baptiste Guimet won with his synthetic dye, soon known as "French ultramarine". Other artificial variants were developed at the same time or shortly afterwards.

# YVES KLEIN

Born in Nice in 1928, French painter, sculptor, and performance artist Yves Klein wanted to do blue differently. Dissatisfied with artificial ultramarine, he went ahead and developed his own shade of blue, International Klein Blue (IKB). Pure ultramarine served as a model—Klein was mesmerized by the depth of it—but the basis for his shade was the synthetic variant mixed with the binding agent Rhodopas M60A. The result was a velvety matt tone that drew the viewer into the picture or object. Klein's monochrome works attracted a lot of attention in the 1950s, but the artist's premature demise shows that working with colors can be a risky business. Klein, who applied his paint without protective equipment and with great physical exertion, died aged 34.

One of the most popular genres of American music, the Blues originated in the Southern States of the United States around the 1860s. With its roots in African-American work songs and spirituals, the form is characterized by a call-and-response pattern and specific chord progressions, most famously the twelve-bar blues. The name "the blues" probably originated in the 17$^{th}$-century English expression "the blue devils" which described severe alcohol withdrawal. Over time, "the blues" came to mean a general state of agitation and depression. Early blues music frequently took the form of a loose narrative, often relating to racial discrimination against African-Americans.

# THE BLUES

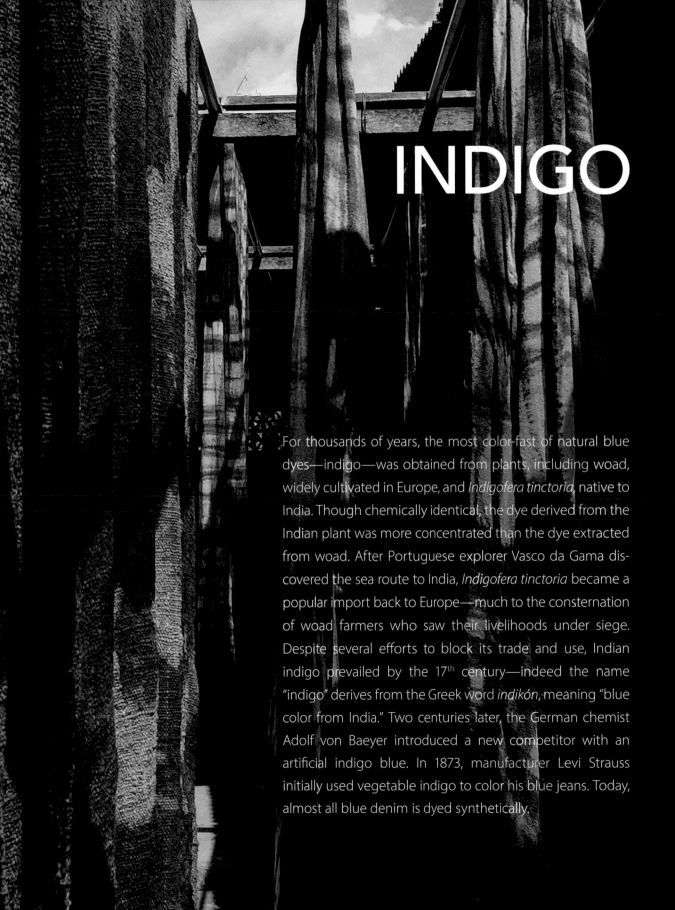

# INDIGO

For thousands of years, the most color-fast of natural blue dyes—indigo—was obtained from plants, including woad, widely cultivated in Europe, and *Indigofera tinctoria*, native to India. Though chemically identical, the dye derived from the Indian plant was more concentrated than the dye extracted from woad. After Portuguese explorer Vasco da Gama discovered the sea route to India, *Indigofera tinctoria* became a popular import back to Europe—much to the consternation of woad farmers who saw their livelihoods under siege. Despite several efforts to block its trade and use, Indian indigo prevailed by the 17th century—indeed the name "indigo" derives from the Greek word *indikón*, meaning "blue color from India." Two centuries later, the German chemist Adolf von Baeyer introduced a new competitor with an artificial indigo blue. In 1873, manufacturer Levi Strauss initially used vegetable indigo to color his blue jeans. Today, almost all blue denim is dyed synthetically.

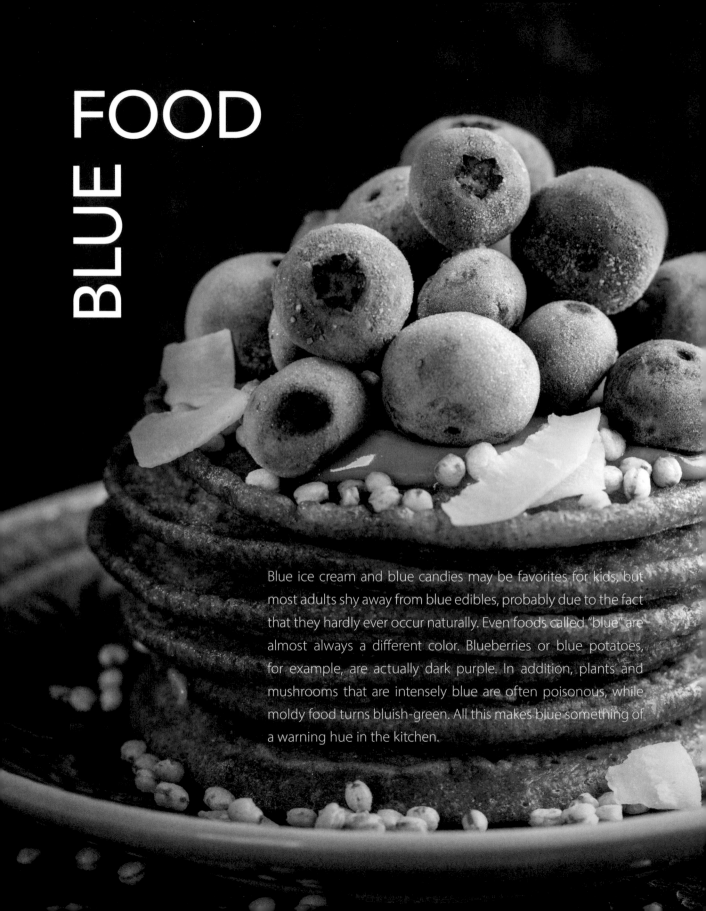

# BLUE FOOD

Blue ice cream and blue candies may be favorites for kids, but most adults shy away from blue edibles, probably due to the fact that they hardly ever occur naturally. Even foods called "blue" are almost always a different color. Blueberries or blue potatoes, for example, are actually dark purple. In addition, plants and mushrooms that are intensely blue are often poisonous, while moldy food turns bluish-green. All this makes blue something of a warning hue in the kitchen.

# SPIRULINA

When it comes to artificial blue coloring for confectionary, the food industry uses spirulina, a type of cyanobacteria, also known as blue-green algae. Spirulina is best known as a dietary supplement, available in powder or tablet form. The so-called superfood is said to aid weight loss and have numerous positive health effects, but this has not been proven. The dye can be obtained relatively easily; the half-millimeter bacterium only needs to be dried and ground.

# THE BLUE CITY

The Indian city of Jodphur is also known as the Blue City, inspired by the blue houses that characterize its architecture. The second largest city in the state of Rajasthan, Jodhpur was founded in the 15$^{th}$ century. Much of the original population came from the highest Brahmin caste, for whom blue was a status symbol. For a time, only the Brahmin were permitted to live in blue houses. Subsequently, the custom was also extended to non-Brahmins. The characteristic Jodhpur blue is achieved with an indigo coating mixed with lime paint.

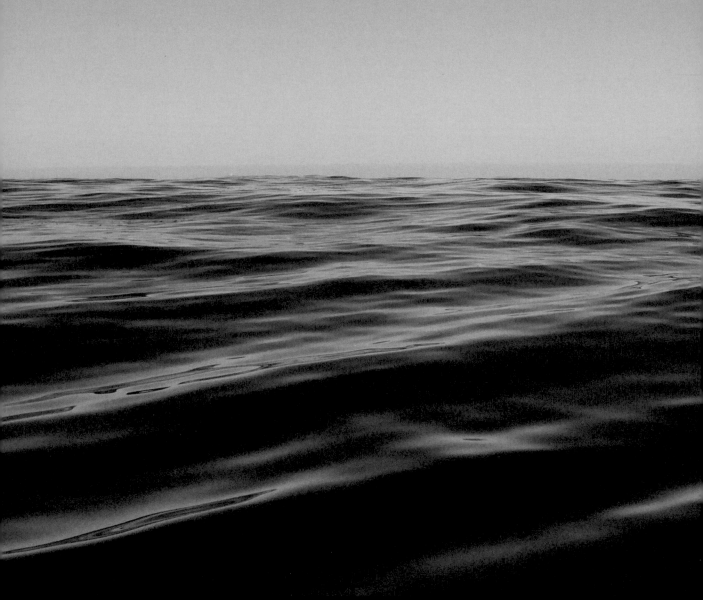

# FAVORITE COLOR

Studies show that blue is the most popular color worldwide. Perhaps it is because every person, even those who are visually-impaired, has a receptor for blue light in their eyes. These days, we encounter this light not only first thing in the morning with daybreak, but also on our many digital devices, including TVs, computers, smartphones, and tablets. Blue is also associated with many positive properties. It is the color of vastness and infinity, trust and harmony. In Europe, the color was not always popular; the ancient Romans associated blue with barbarism. It was not until the 12th century that the tide turned and blue became popular as a "divine" color in church painting.

# TURQUOISE

TUTANKHAMUN
HATHOR, GODDESS OF TURQUOISE
BIRD EGGS
CARIBBEAN
AQUAMARINE
THE KINGFISHER
DWARF GECKO
ORIGIN
TIFFANY BLUE
COLDEST COLOR

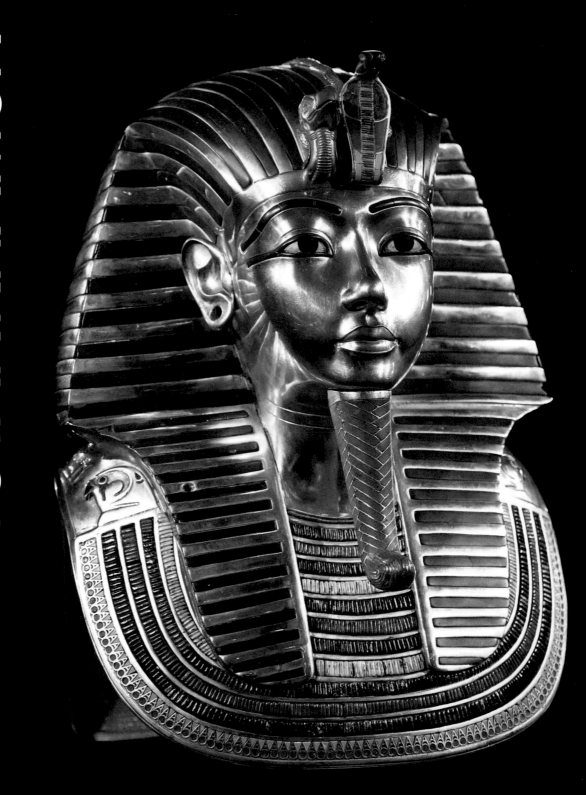

TUTANKHAMUN

The world-famous death mask of the child king Tutankhamun is also decorated with turquoise inlays. Discovered in a burial chamber in the Valley of the Kings in 1922, the 11-kilogram (22.5-pound) mask was intended as a perfect, beautiful image of the ruler rather than an actual likeness. For the Egyptians, death did not mean the end, but only the beginning, meaning the body had to be preserved through mummification for the afterlife. Gifts in the house of the dead, the grave, were supposed to make his stay more comfortable. The valuable materials used in death masks—sometimes real, sometimes fake—had meanings and functions linked to the god of the dead, Osiris.

# HATHOR, GODDESS OF TURQUOISE

The mineral turquoise has long been popular as a gemstone and for inlay patterning. Already in pre-dynastic Egypt, there was organized turquoise mining; the Sinai area is documented as a mining site around 3200 BC. Back then, the green-blue stone known as *Mefkhat* was associated with the deity Hathor, goddess of many things including love, beauty, music, and dancing. Her far-reaching protection extended not only to the dead, the country and foreigners, but also to the royal turquoise mines and their workers. Due to its popularity, it didn't take long for turquoise to be faked, for example from blue glass.

Some species of birds lay blue to bluish-looking eggs. One of the most remarkable are the speckled turquoise eggs of the song thrush. Egg colors result from two prime color pigments: the blue biliverdin and the red-brown protoporphyrin. In the case of the thrush, the blue pigment is responsible for the uniform coloring of the eggshell and the red-brown pigment for the dark speckled pattern. The quantity and distribution of the two pigments varies from species to species and results in a variety of egg colors which all fulfill certain functions. Generally, the different colors are adapted to native habitat and serve as camouflage from predators, but in this case, a rather gaudy variant, they can also act as a deterrent. The color also plays a role in thermoregulation: darker eggs are more likely to be found in colder regions, the lighter ones in warmer areas.

# BIRD EGGS

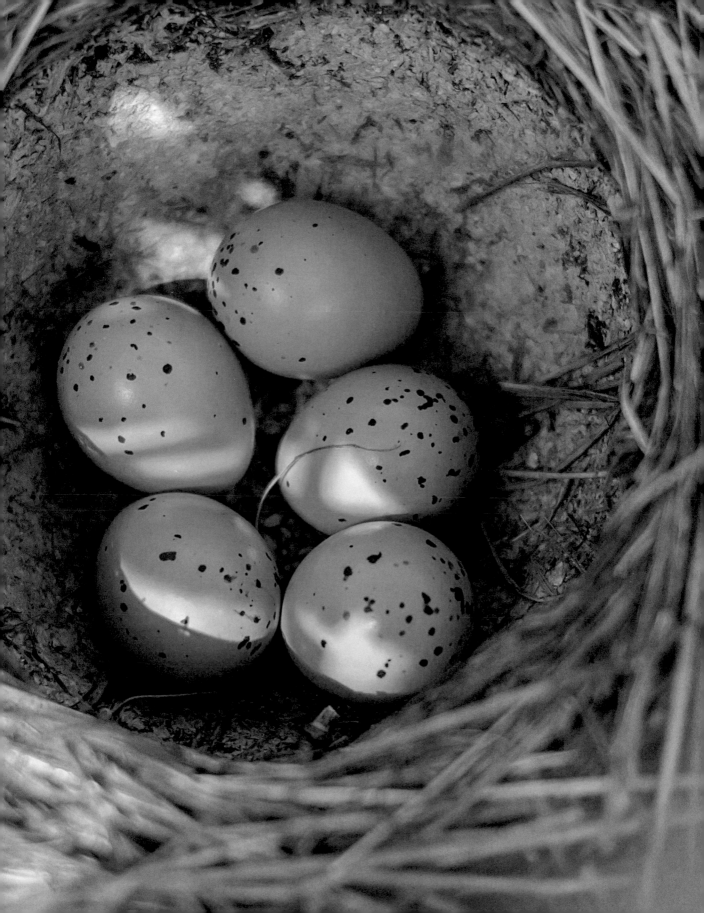

Sea water usually appears blue because the blue part of light can penetrate deeper into the water than the other spectral colors. The different hues and shades of a body of water are influenced by the quantity and quality of resident bacteria, algae, minerals, sand and mud, resulting in anything from milky white to dark blue, green, or turquoise blue. The color of the sea in the South Pacific and the Caribbean is perceived as a mixture of green and blue—the coveted turquoise water. This paradisiacal color is mainly present nearest to the beach, where white coral sand in the shallow water reflects the sunlight. Green shimmering water also indicates a high level of phytoplankton, a food source for organisms living on the sea floor. If the phytoplankton concentration is high, the waters will likely be home to a rich variety of fish and other creatures.

# CARIBBEAN

The name already speaks of the sea: Aquamarine literally means "water of the sea" and is made up of the Latin words *aqua* (water) and *marinus* (belonging to the sea). The aquamarine stone, which belongs to the mineral class of beryls, was in ancient times a symbol of luck and a guarantee of eternal youth. In addition, it was said to appease the god of the sea, Neptune. When sailors faced stormy waters, they threw precious aquamarine amulets overboard to calm his temper. The aquamarine has a spectrum of different shades of blue, ranging from an aquamarine pastel blue to brilliant turquoise, ocean-like shades of green to an intense deep blue—the most sought-after shade—to a glowing dark blue. The more intense the color, the higher the price of the stone. Heating can help make the color deeper. Aquamarines from the Brazilian mine Santa Maria de Itabira are sold under the name "Santa Maria," a name that has become synonymous with quality and the deep blue variant. The heavyweights among aquamarines also come from Brazil: in 1910, an 110.5-kilogram (244-pound) stone was found on the Marambaia River. In 1922, a 400-kilogram (882-pound) stone—the largest and heaviest known to-date—was discovered at the Galilea mine near Governador Valadares.

# AQUAMARINE

# THE KINGFISHER

The sparrow-sized bird that lives by the water has one of the most magnificent plumages in the animal kingdom: a color symphony of blue, blue-green, and turquoise tones on the back and head, contrasting impressively with a rust-red belly. Generally shy birds, kingfishers nevertheless feature prominently in human culture. In Polynesia, the kingfisher was considered sacred and believed to have control over the seas and waves. Bornean culture also venerated kingfishers as both good and bad omens. In Greek mythology, the figures Alcyone and Ceyx were turned into kingfishers. Today, a number of kingfisher species are threatened by human activity and in danger of extinction.

*Lygodactylus williamsi*, the male dwarf gecko, reveals its striking, turquoise-blue color only under bright light and at warm temperatures. The geckos are diminutive in both size and habitat. Growing up to 8.5 centimeters (3.4 inches) tall, they now live on a mere eight square kilometer (three square mile) plot of the Kimboza Forest reserve in Tanzania, located at an altitude of 350 meters (1,148 feet). Critically endangered, the Lygodactylus williamsi has been banned from sale without a permit since February 2017. Its already threatened status is made even more precarious by the fact that its natural screwpine tree habitat is now also on the red list of the International Union for Conservation of Nature (IUCN).

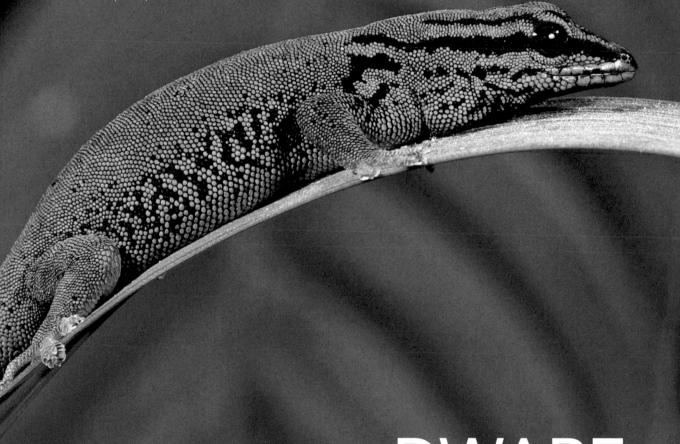

# DWARF GECKO

# ORIGIN

The color name turquoise is derived from the characteristic color of the mineral stone—but with some confusion along the way. Until the 13<sup>th</sup> century, the mineral was called *kallaite*, after the ancient Greek word *kalláinos*, which means something like "shining in the colors blue and green." It was then replaced by turquoise, derived from the French term *pierre turquoise* or "Turkish stone," because it was thought that the stone came from Turkey. In fact, it was imported from Persia but passed through Turkey on the trade route.

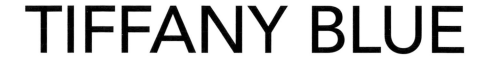

# TIFFANY BLUE

The luxury jewelry retailer Tiffany & Co. opened on Broadway 259, New York in 1837. Its famous Tiffany Blue, a turquoise, was first used in 1845 for the cover of Tiffany's *Blue Book*, and then elevated to corporate color, trademarked in 1998. The iconic Tiffany's Blue Box fascinated buyers and aspiring buyers. Also, company co-founder Charles Lewis Tiffany made sure that the coveted packaging was only available in connection with a jewelry purchase—a successful marketing ploy that he discussed with the *New York Sun* in 1906. According to Tiffany, no money in the world could buy the turquoise box, but those interested would get one for free if they chose Tiffany jewelry. The color, also known as robin egg blue, was probably chosen because turquoise was a particularly popular gemstone in the 19th century.

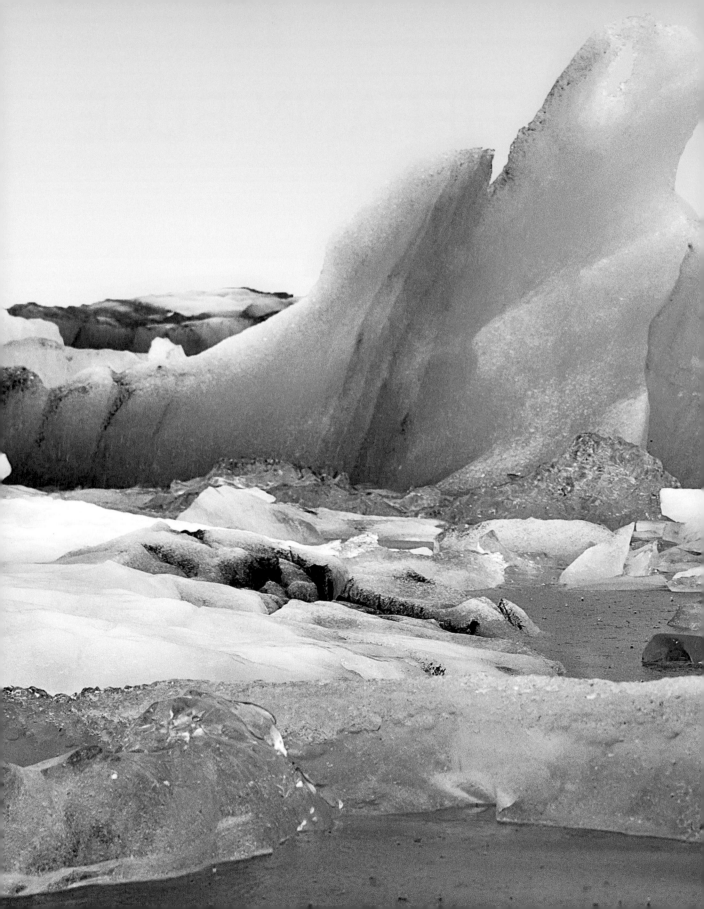

Turquoise, also known as cyan, aquamarine, green-blue, or blue-green (depending on which color dominates), lies somewhere between blue and green, and is a tone that cannot be defined uniformly. Light turquoise is the color of ice and cold and is associated with glaciers, frost, and frozen lakes. In the world of colors, light shades of turquoise are perceived as the coldest of all colors. The color is cool, refreshing, and invigorating—even Caribbean water, evocative of tropical shores, provides refreshing relief from the sun.

COLDEST COLOR

# GREEN

# THE COLOR OF LIFE

Everyone knows that green is the color of life and nature: green means growth and freshness. Chlorophyll or leaf green, a natural dye, is a hallmark of photosynthesis. The term unites the Greek word *chlōrós*, meaning both "light green" and "fresh," with *phýllon*, meaning "leaf." Green is everything that is close to nature—ecological, growing and fertile. In this context, green has also become a symbol of hope, spring, and new beginnings. In addition to these very earthly components, the green glimmer of hope is also anchored in the Bible, as in the Revelation of John 4,3: "And a rainbow arched over the throne, which looked like an emerald."

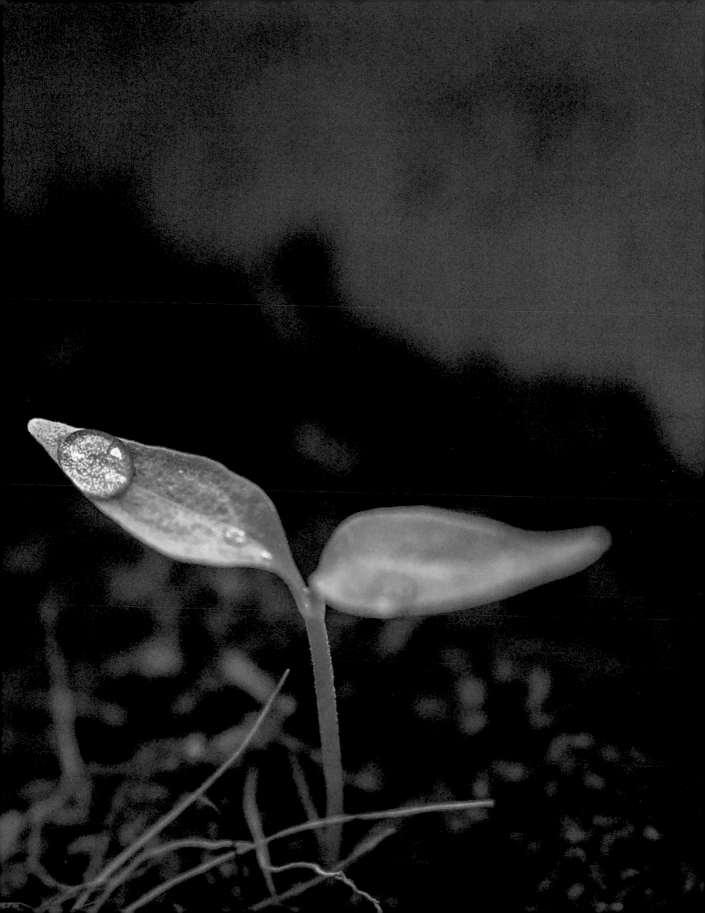

# MOLD

Green isn't always fresh. In fact, foods that have green mold are generally to be avoided. In this instance, green isn't a sign of new beginnings, but rather organic decay. The mold, a type of fungus, produces spores which take on a green hue. Green mold is particularly common on citrus fruits like oranges and grapefruit, along with porous, starch-heavy foods like bread. Even if it is only visible on the surface, the mold roots may lie deep in the food.

POISON GREEN

For a long time, strong green pigments were poisonous. The most famous of these is Paris green, also known as Schweinfurt green or Vienna green, made of an arsenic compound. Despite its dubious ingredient, Paris green was a popular painter's color in the 19th century, because it shone with unrivaled intensity and did not change when exposed to light. For a long time, there was speculation that Napoleon Bonaparte died of creeping arsenic poisoning from the green in his upholstery, wallpaper, and dyed leather. The theory has since been refuted; after examining hair samples from Napoleon and his family members, it was found that they all had the same levels arsenic content, meaning Napoleon had not suffered any excess exposure. But the vicious toxicity of Paris green is undisputed; it has also been heavily used as insecticide and rat poison.

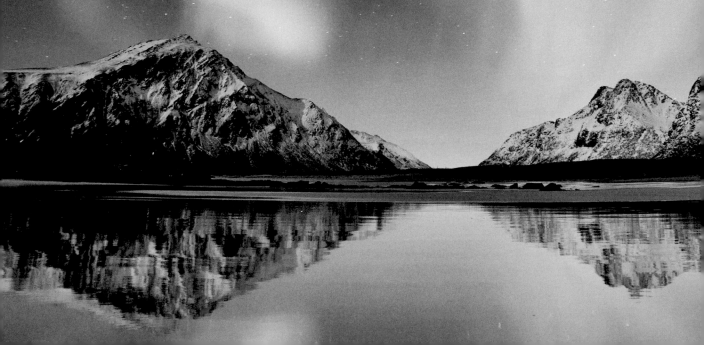

POLAR LIGHT

The polar lights are glowing phenomena in the night sky that occur in the polar regions and are especially visible during the winter months. The northern lights (*Aurora borealis*) and the southern lights (*Aurora australis*) arise when matter is ejected into space by the sun. Also known as the solar wind, these electrically-charged particles travel at great speed and create an electric voltage when they reach the earth's magnetic field. When the electrons meet the earth's own oxygen and nitrogen atoms, they form auroras. Depending on the height of this encounter, different colors emerge, most particularly green. The effect is especially visible at the poles, because it is here that it is closest to earth. The phenomena have both fascinated and frightened people since ancient times. Like other natural phenomena that were not yet explained, they were variously interpreted as magical, mystical, or a harbinger of disaster. After the physical mystery was explained, a new anxiety has taken its place: aurora tourism. Every year, thousands of professional and hobby photographers descend on the polar regions with cameras aimed at the sky.

# JEALOUSY

The color green has a long association with feelings of jealousy and envy. Back in the 7th century BC, the Greek poet Sappho wrote of a jilted lover being green. Shakespeare's play Othello refers to jealousy as "the green-eyed monster which doth mock the meat it feeds on." Today, we still hear the expression "green with envy." The connection probably dates back to Ancient Greek medicine, which attributed jealousy to an excess of bodily fluid called "green bile."

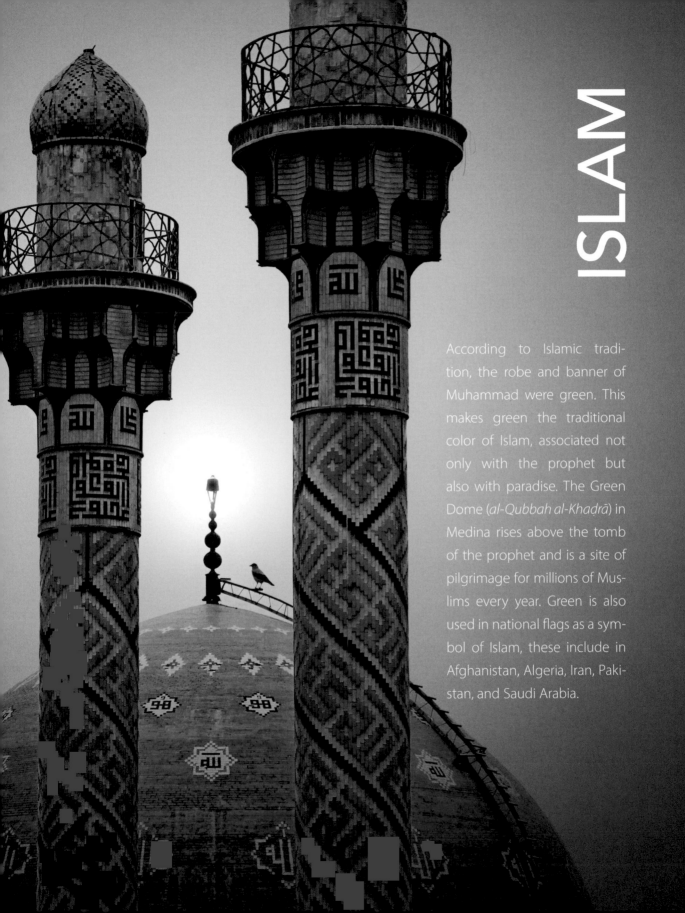

# ISLAM

According to Islamic tradition, the robe and banner of Muhammad were green. This makes green the traditional color of Islam, associated not only with the prophet but also with paradise. The Green Dome (*al-Qubbah al-Khaḍrā*) in Medina rises above the tomb of the prophet and is a site of pilgrimage for millions of Muslims every year. Green is also used in national flags as a symbol of Islam, these include in Afghanistan, Algeria, Iran, Pakistan, and Saudi Arabia.

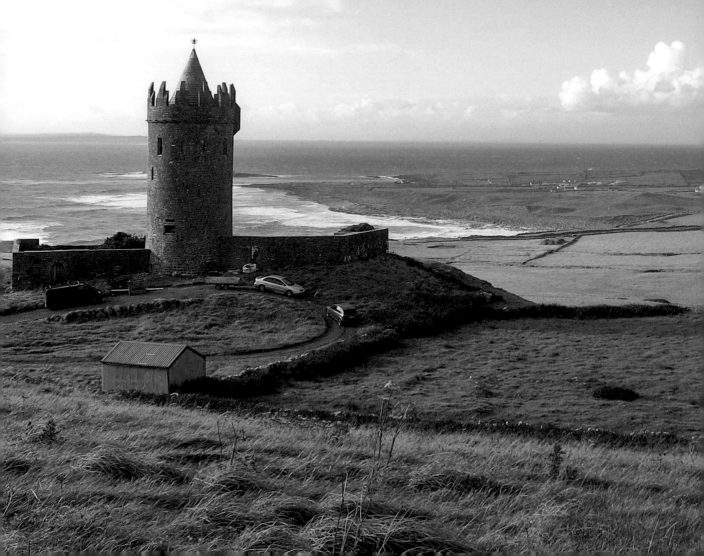

# THE EMERALD ISLE

Lush meadows, pastures, extensive moors, and moss-covered hills: the island of Ireland is especially green. The landscape is thanks to regular rainfall and a mild climate, with only moderate seasonal changes. Compared to Central Europe, Irish summers are relatively cool, while the winters are relatively mild. The term "The Emerald Isle" first appeared in print in a poem in 1795. Green also features on the Republic of Ireland's national flag, and in the annual celebration of Saint Patrick, patron saint of Ireland.

# GREEN CARD

In the 19th and early 20th centuries, the USA was the number one immigration country in the world. In 1933, arrival became more complicated after the Supreme Court introduced the U.S. Immigration and Naturalization Service (INS). About 20 years later, rules were given legal shape in the Alien Registration Act. With this, a bright green ID card should be issued to every "alien" (foreigner) upon entry to the country. Thus the Green Card was born—now one of the most coveted documents in the world. In fact, the card was at times blue, pink, and purple, but the original green name persisted until the card turned green again on May 11, 2010.

# GO!

Today, green signals that we can drive ahead, but it was a journey from the first traffic light to the green traffic light. The system was inspired by railroad signals, which engineer John Peake Knight transferred to road traffic in 1868. The original system was in front of the Houses of Parliament in London, initially functioning with directional signals during the day, and red and green lights by night. But why these colors? Why not yellow and blue? The explanation is a biological one; our eyes usually perceive the complementary colors red and green most vividly. The designation "to give the green light," broadly signaling access or consent, has since established itself as a positive formulation way beyond the road. All the more understandable if you add up the minutes that every person spends waiting at a red light.

# EXIT

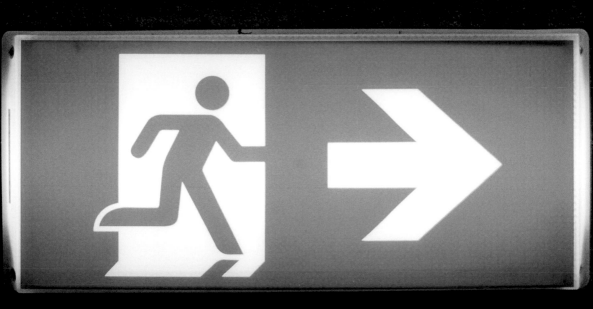

The green and white emergency exit sign is a standard feature in any public space—whether an airplane, hotel, or museum. It is mandatory that the sign features an arrow, which—in combination with the vivid green color—clearly communicates the safest escape route, or the way to the nearest first aid station. Since 2013, the color has been standardized by the ISO 7010, an international technical standard for hazard symbols and safety signs. The color, RAL 6032, is precisely defined, and the sign should communicate its function without needing any text. Technical innovations have also equipped the sign with a fluorescent material that can store daylight and thus self-illuminate the way to rescue, even in the case of smoke or power failure.

# BROWN

No color provokes such opposing reactions as brown. And, according to an international study across ten countries, it is the least popular color after gray. The color can connote waste, dirt, and austerity. It is seen as both utilitarian and dull. But brown is also connected to the earth and nature, to cocoa and coffee, baking and bread. As much as it can provoke displeasure or even revulsion, brown can also arouse feelings of coziness, authenticity, and comfort.

# A LOVE-HATE RELATIONSHIP

For many people around the globe, coffee is a daily ritual. There are many myths about its origins, but what we know for sure is that the coffee plant originated in Africa and reached other continents via the Arab world. According to legend, shepherds from the Kaffa region of Ethiopia noticed that the animals who had eaten coffee berries were particularly excited. When the shepherds made their own infusion with the berries, they felt the same stimulant effects. The coffee berries—also known as coffee cherries—were brought home by Yemeni traders, but spoiled quickly en route, so in the 14th and 15th centuries, large areas of coffee plantations opened up in Yemen itself. The most important trading point was the port town of Al-Makha, or Mocha. Through the expansion of the Ottoman Empire, coffee reached Asia Minor and Southeast Europe by the 16th century. Today, coffee plants are cultivated in over 70 countries, primarily in the equatorial regions.

# BROWN SUGAR

Brown sugar is never simply brown sugar. Among the brown varieties of sugar, there is traditional rock brown sugar; raw cane sugar—at least partially refined; and whole brown sugar, also known as Muscovado, made from the unrefined sweetness of sugar cane juice. Brown sugar looks more natural than white sugar but cannot really be said to be healthier. White household sugar, also known as granulated sugar, is made from sugar beet or sugar cane and obtained through refining, a repetitive process of boiling, filtering, crystallizing, and centrifuging which eradicates minerals and vitamins along the way. Brown sugar, by contrast, contains some residue of the coloring molasses and with it very small amounts of vitamins and minerals—but it still damages teeth and can contribute to heart disease, obesity, and diabetes.

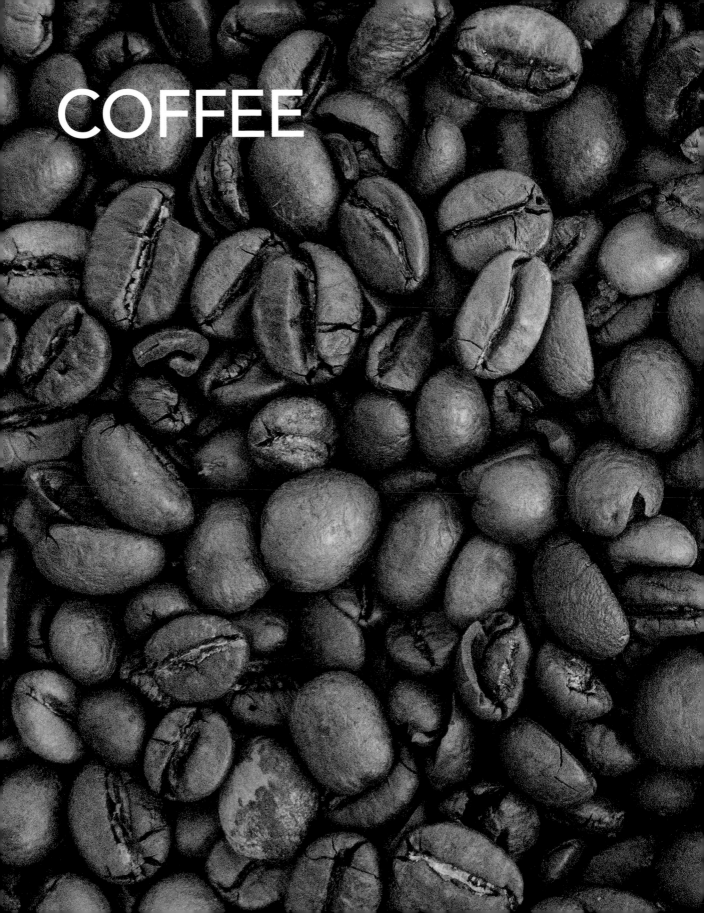

COFFEE

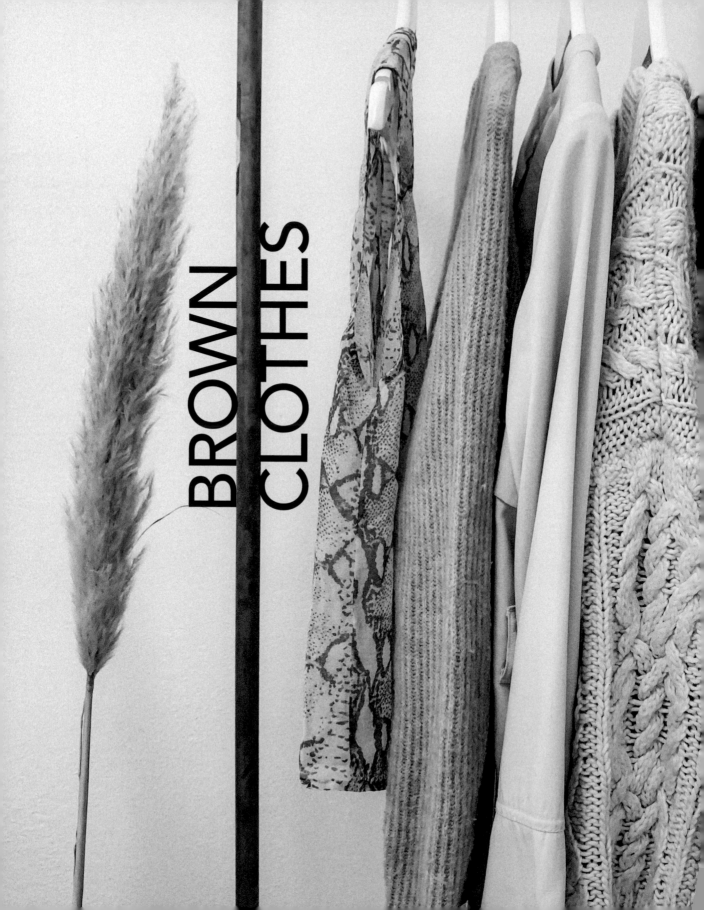

BROWN
CLOTHES

When it comes to clothing, brown has rarely been considered a desirable color. In the Middle Ages, it was the color of poverty, worn only by those who could not afford dyed fabrics. Monks of the Franciscan and Capuchin orders wore brown or gray robes as a sign of their humility. In the 18th century, the color was gradually established among the bourgeoisie, but then fell firmly out of fashion when it became the official color of the Nazi party. After a brief revival in the 1970s, brown has stayed in the sartorial backdrop—until the 2020s, when shades of chocolate, caramel, and nut are making a comeback. In times of social change, people are drawn to brown's positive associations of stability and nature.

# UNIFORM

Since the 18th century, brown has been a popular color for military uniforms, largely because of its wide availability and low visibility. In 1846, soldiers in the British Indian Army, the main military of the British Indian Empire, began to wear a yellow-tan shade known as *khaki*, from the Urdu word for dust-colored. The color made for excellent camouflage in natural surroundings and was subsequently rolled out across the British Army as well as the United States Army, Navy, and Marine Corps. In Nazi Germany, the paramilitary organization of the *Sturmabteilung* wore brown uniforms, and became known as "brown shirts."

# PULLMAN BROWN

One of the few companies that has chosen brown as its corporate color is the United Parcel Service, or UPS. With just 100 US dollars in seed capital, Jim Casey and Claude Ryan founded the American Messenger Company in Seattle in 1907. Initially, courier shipments were still delivered by bicycle. It wasn't until 1913 that the first delivery van joined the fleet. In 1919, the company expanded to California, was renamed UPS, and introduced the so-called Pullman Brown across its company uniforms and vans. The color stands for a dependable, down-to-earth service and has been trademark protected since 1998.

Earth pigments are naturally-occurring pigments that have been used for coloration since prehistoric times. Mainly extracted through surface mining, earth pigments are ground and washed to remove water-soluble elements. For some pigments, the color can be deepened by heating, but it is only with the help of a suitable binding agent such as glue or oil that the pigment can become a usable color. Earth pigments, which include ochre, sienna, and umber are both colorfast and resistant to aging. Prehistoric rock paintings in earth pigments are preserved to this day.

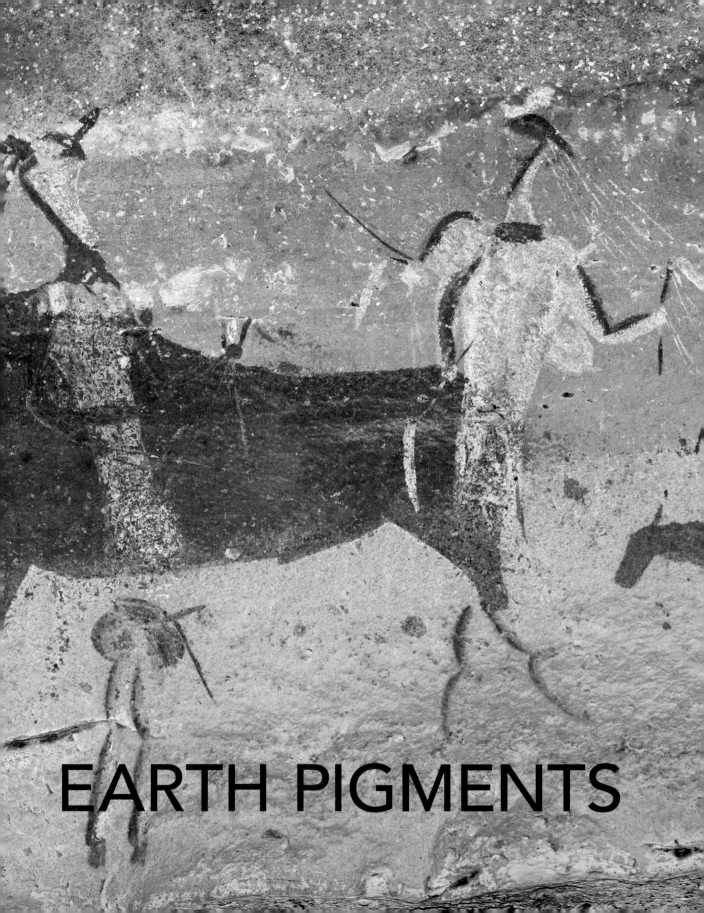

EARTH PIGMENTS

COZINESS

Even before its fashion revival, brown was making a comeback in interior design. In living areas in particular, warm brown tones are often used to express coziness and a closeness to nature. The many shades and structures of the color, be it in wood or leather, give rooms a relaxing atmosphere as well as a sense of quality and durability.

# BEAUTY IDEAL

Coco Chanel not only shaped the style of clothes; she also accidentally made the suntan fashionable. When the iconic designer forgot a parasol on a boating trip and disembarked with a suntan, tanned skin—long associated with working class labor—suddenly looked like leisurely chic. By the 1960s, the suntan was a firm beauty ideal for much of the western world, with the likes of Brigitte Bardot often pictured in sunbathing splendor. The tan came to be seen as youthful, affluent, and athletic—but not without risk. Since the 1980s, numerous awareness campaigns have communicated the dangers of excess UV exposure.

There were cocoa trees in South America some 5,000 years ago, but it was the Mayan and Aztec cultures of Central America who first consecrated cocoa as a gift from the gods. By drying, grinding, and mixing the cocoa beans with water, they created a liquid chocolate drink reserved for the ruling elite, for triumphant warriors, and for special occasions like religious rituals. In the 16th century, Spanish conqueror Hernán Cortés brought the cocoa—in Spanish *cacao*—bean to Europe. At first, the bean was still sweetened and drunk in liquid form; Europeans found the taste too bitter on its own. In 1828, Dutchman Coenraad J. van Houten succeeded in producing cocoa powder. Further industrialization made it possible to develop new cocoa products and make them accessible to the general consumer. In 1847, English company J. S. Fry & Sons produced the first chocolate bar. The most popular variety—milk chocolate—was not developed until 1875 by the Swiss chocolatier, Daniel Peter.

# COCOA

# GRAY

When it comes to favorite colors, gray hardly plays a role. When it comes to favorite car colors, things look very different. For years, gray has been the top choice for new car owners. The color's neutral, high-quality as well as timeless associations are certainly part of the appeal. To cater to the market, car manufacturers offer a seemingly limitless palette of gray tones.

# CAR COLOR

Colloquially, gray matter refers to brain cells. In medicine, the term refers to neurons and other cells of the central nervous system, found in the brain, brain stem, cerebellum and the spinal cord. Technically, gray matter has a light gray color with pink or yellowish hues. Alcohol consumption and video games have been shown to reduce gray matter, while meditation has been shown to change its structure.

# GRAY MATTER

# GRAY SUIT

In 19th-century fashion, women's clothing trends were largely set by Paris, but for menswear, London set the style stakes. Over the course of the century, bright colors disappeared from men's fashion, and were replaced by a black or charcoal gray frock coat in winter and a lighter gray palette in summer. By the early 20th century, the frockcoat was replaced by the lounge suit, and later evolved into the business suit. Along with black, light gray, and dark gray remained the most popular colors, exuding competence, diplomacy, and professionalism.

# ALLROUNDER

One of the two Pantone Colors of the Year 2021 is Ultimate Gray. If you take a closer look at the Pantone color table, you'll see a significant number of other gray shades—many with poetic names like Weather Vane, Night Owl, and Lava Smoke. Gray is not only a favorite car color; it is also a long-running hit on the world's catwalks and in interior design. Easy to combine, gray makes almost every other color pop, and, with its variety of light to dark tones, offers a shade for every taste and situation.

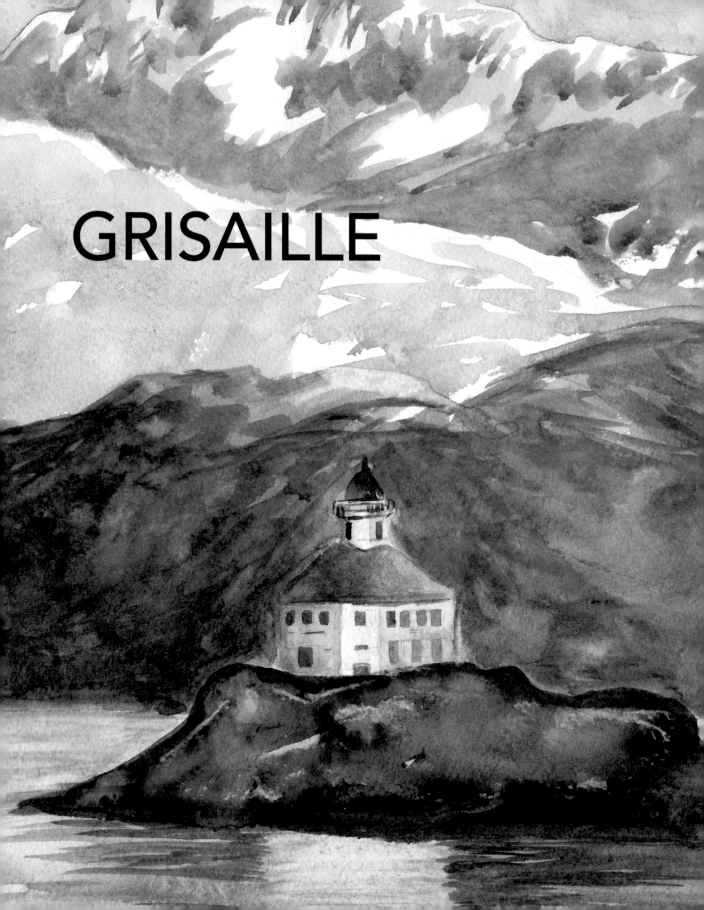

# GRISAILLE

Grisaille is a painting made entirely in shades of gray, or a grayish color. Historically, grisaille was often used for the preparatory underpainting of an oil painting, or as a model for an engraver to work from. Other examples of grisaille can be found in final works, for example on the Ghent Altarpiece, and in Giotto's frescoes at the Scrovegni Chapel in Padua, Italy. Modern examples of grisaille include Picasso's *Guernica*, where the gray also connotes the industrialization of modern warfare.

# GRAY GOBLINS

In folklore, gray is often associated with goblins, elves, and other mischievous creatures. Scandinavian folklore in particular often depicts gnomes in gray clothing. This is partly because of their association with dusk, and partly because such creatures were believed to exist beyond the traditional moral binary symbolized by black and white. The writer J. R. R. Tolkien made use of gray symbolism in his works *The Hobbit* and *The Lord of the Rings*. The wizard Gandalf is also called the Gray Pilgrim; settings include the Gray Havens and the gray mountains, and other characters include the Gray Elves.

Gray, a mixture of black and white, has a figurative place between light and darkness, light and death. It is often used to describe an intermediate state or transition area. A "gray area" is an ambiguous issue, open to interpretation, or the area between two mutually exclusive states or categories, like legal and illegal. Ghosts, caught between life (white) and death (black), are often represented in art and film with the color gray.

# BETWEEN LIFE AND DEATH

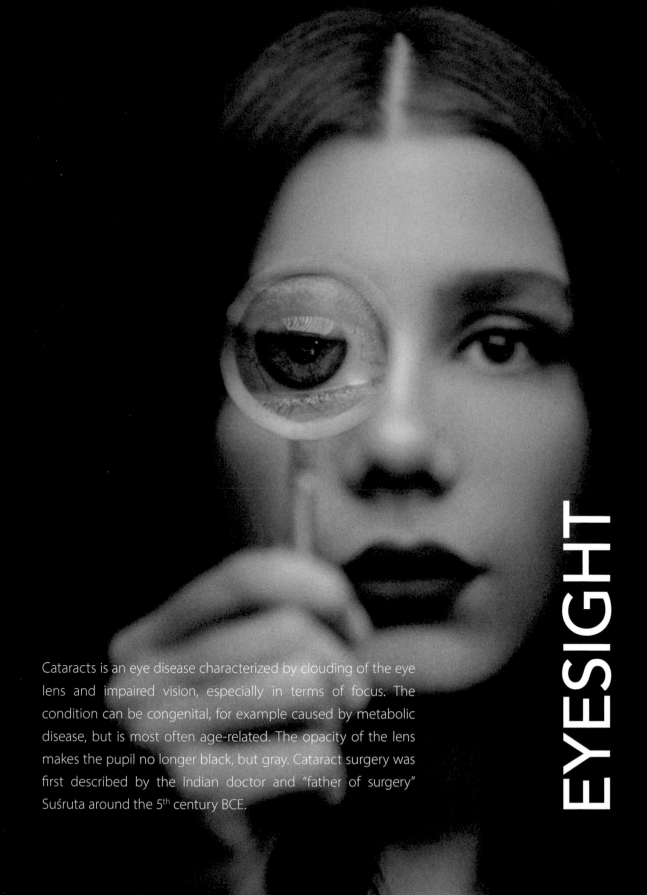

Cataracts is an eye disease characterized by clouding of the eye lens and impaired vision, especially in terms of focus. The condition can be congenital, for example caused by metabolic disease, but is most often age-related. The opacity of the lens makes the pupil no longer black, but gray. Cataract surgery was first described by the Indian doctor and "father of surgery" Suśruta around the 5th century BCE.

EYESIGHT

Gray is widely associated with ageing but in fact hair actually turns white, not gray, as we get older. The strands appear gray because the color of the original hair color still shows through. The change is due to depleting production of melanin, which gives our hair its color, and which decreases with age. Researchers at Harvard University recently discovered that whitening hair can also be caused by stress.

# GRAY HAIR

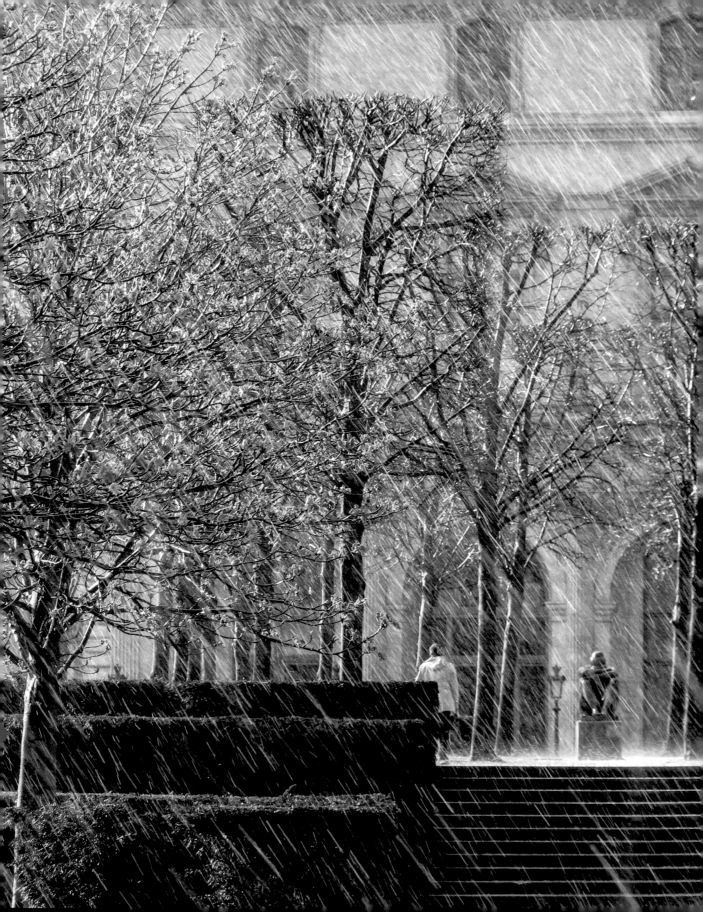

Whether clouds appear white or gray depends on their depth. Fluffy white clouds typical of a summer sky seem white because they scatter sunlight through their tiny water droplets, sending white light to our eyes. As clouds become larger and denser with more and more water, the white light can no longer penetrate, making the cloud look gray. The darkest gray clouds typically appear just before a thunderstorm.

# RAIN CLOUDS

# BLACK

BLACK THURSDAY
BLACK MARKET
THE LITTLE BLACK DRESS
BLACK MAMBA
GOTH
BLACK HOLE
THE BLACK DEATH
BLACK SQUARE
BLACK POWER
BLACK CATS

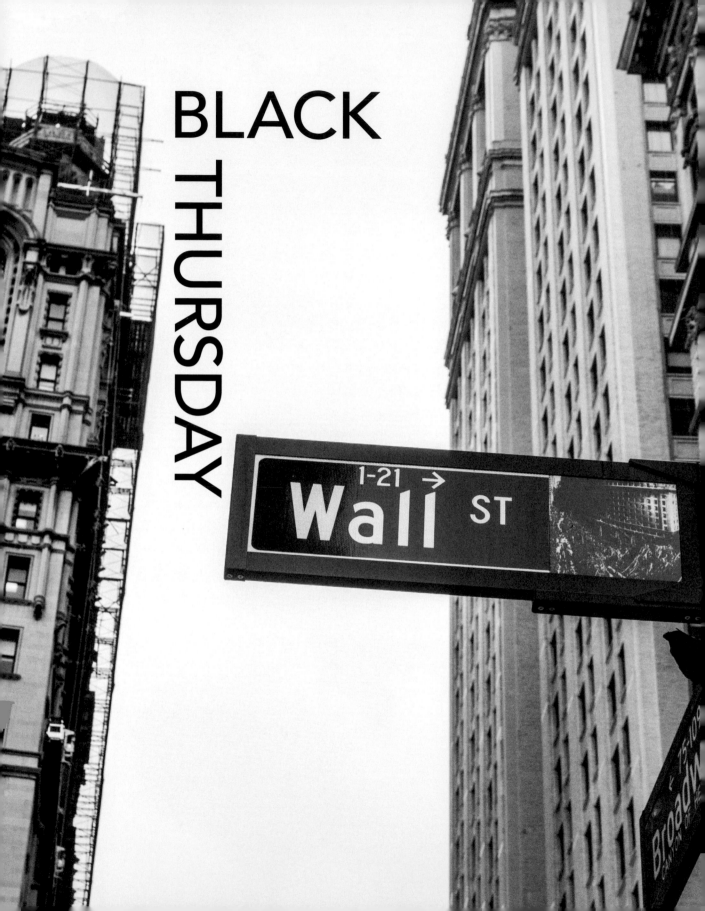

On Thursday, October 24, 1929, 10 a.m., the New York Stock Exchange was hit with massive price losses. In just half an hour, 1.6 million investors had sold their shares. Growing panic set off a chain reaction of further sales. In New York's financial district, the Dow Jones stock index plummeted. The global crisis that ensued had been preceded by an economic boom. Through the general upswing and optimism, small investors had been seduced into buying shares. Loans, which in turn were used to buy securities, were sometimes granted without existing collateral, while the companies receiving investment were wrongly endowed. By 1929, it became clear that the previously flourishing market was saturated with seemingly unending growth; prices stagnated and a speculative bubble developed, only to burst on that October morning. Around 11,000 of 25,000 US banks closed, a lack of corporate credit led to layoffs, and American banks withdrew loans for European companies and states.

# BLACK MARKET

The color black carries association with the unofficial, unauthorized, or forbidden. The "black market" is a clandestine, illegal market that violates official regulations. "Black money" is the proceeds of an illegal transaction. Black markets tend to flourish in times of conflict, when essential resources like food or gasoline are hard to come by. During World War II, rationing and price controls encouraged widespread black market activity. Other goods traded on the black market include weapons, illegal drugs, protected animal species, and sensitive data.

It was in a 1926 edition of *Vogue* that Gabrielle (aka Coco) Chanel first presented the little black dress. The design caused a scandal and laid the foundation for a fashion revolution. During the First World War, many women had discovered new levels of emancipation. Taking on jobs previously assigned to men, they'd abandoned their corsets for utilitarian work-wear. With her crêpe de Chine black dress, Chanel combined that looser-fitting comfort with leisure. The dress color and casual cut—hanging loosely and just over the knee—were far removed from traditional women's clothing. "This simple dress will become a kind of uniform for all women with taste," said Chanel. *Vogue* dubbed it "Chanel's Ford"—simple and accessible to all. Today, the little black dress is widely considered a wardrobe essential. Constantly reinterpreted by designers, it is the epitome of easy elegance and allure.

# THE LITTLE BLACK DRESS

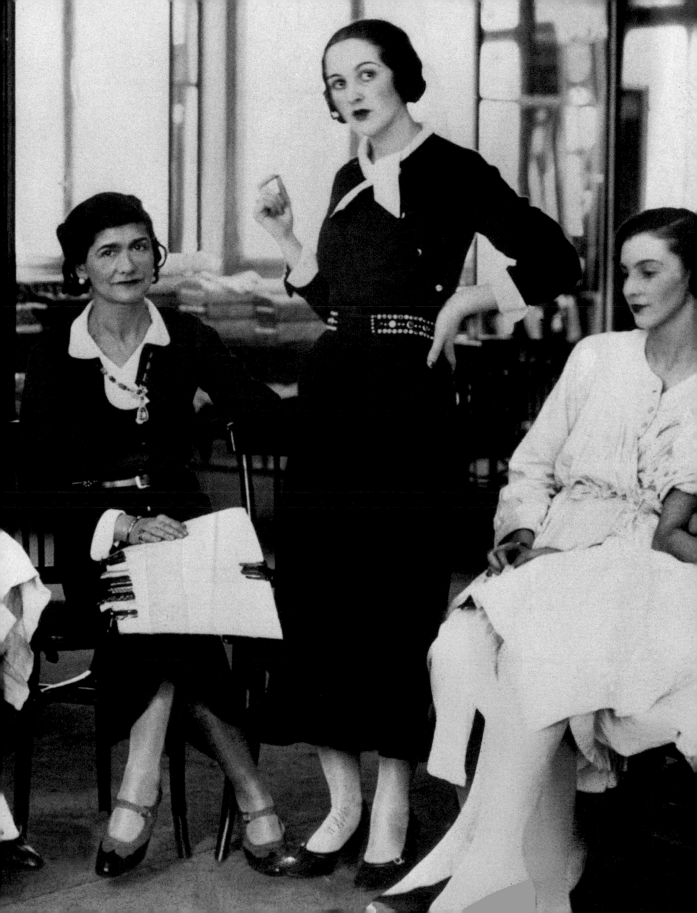

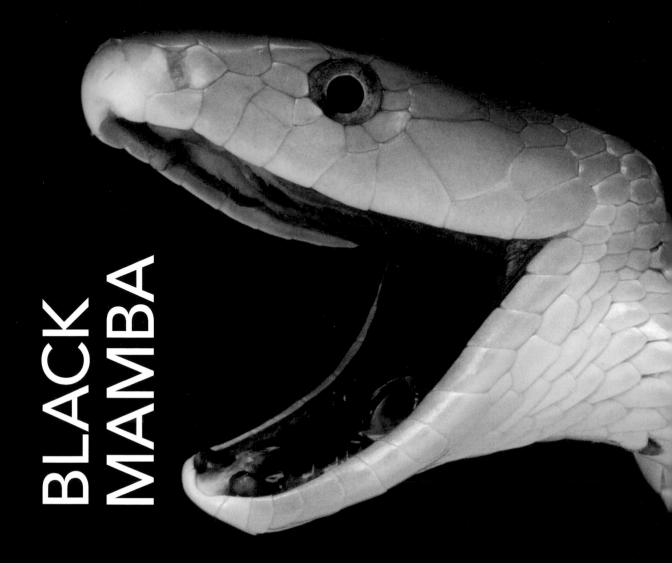

# BLACK MAMBA

The black mamba (*Dendroaspis polylepis*) is found in the savannahs and rocky hills of southern and eastern Africa. It grows up to four meters long and is one of the fastest snakes in the world, covering some 20 kilometers (12 miles) per hour. The snake owes its name to the black (or dark blue) color inside its mouth; most of the snake's external body is olive green or dark brown with a lighter-toned belly. The snake hunts by day, preying on small vertebrates such as birds, and small mammals like rats and mice. The black mamba is one of the world's deadliest snakes; just 10 milligram of its venom can be lethal to humans. Though it tends to be shy in behavior, it can become aggressive if cornered and strike with several fast bites. Before the advent of anti-venom, a black mamba attack was almost always fatal.

Goth subculture first emerged in Britain in the 1970 and 1980s, anchored in the gothic rock music scene. The movement's aesthetic carries the influence of 19th century Gothic fiction, with its emphasis on death, fear, mystery, and awe. Styling and appearance played a central role in Goth culture from the start, with clearly defined ideals and quick recognition value: a pale complexion, high to hollow cheekbones, black-rimmed eyes, black nail polish, dyed-black hair, and solid black, often period-styled, clothing. Silver jewelry, piercings, and fishnet tights are popular accessories. Goth culture continues to evolve and inspire to this day, not least in the fashion world. Alexander McQueen, John Galliano, and Jean Paul Gaultier have all been associated with Goth trends.

# GOTH

# BLACK HOLE

A black hole is a region of spacetime with a gravitational pull so strong that nothing—not even particles or electromagnetic radiation such as light—can escape. Most black holes emerge from the remnants of a large star that has died during a supernova explosion. Though only a couple of dozen black holes have so far been found in our Milky Way, there are thought to be hundreds of millions. By its very nature, a black hole cannot be seen, and can only be detected by the behavior of other matter. Stars passing too close to a black hole can be shred into streamers before being "swallowed."

# THE BLACK DEATH

In 1347, 12 ships from the Black Sea docked at the Sicilian port of Messina. Some of the sailors on board were already dead; others were displaying dreadful symptoms: high fever, swelling, vomiting, and oozing boils. Authorities hastily ordered the ships out of the harbor, but it was too late. Over the next centuries Black Death, a bubonic plague, killed up to 200 million people across Eurasia and North Africa. The plague was transmitted by fleas and body lice, with poor hygiene standards facilitating the spread of disease. The Black Death remains the deadliest pandemic in human history.

# BLACK SQUARE

*Black Square* is an artwork by Kazimir Malevich (1876–1935) often referred to as the "zero point of painting." Malevich created various versions of the work, including a series of oil paintings, lithographs, and drawings. The first painting in the series was exhibited in 1915 at the Last Futurist Exhibition of Paintings 0,10 and is widely considered the origin of Suprematism. It was supposed to "give supremacy to sensation." Despite an initial backlash, the work had enormous influence. *Black Square* became an icon of art history. Appropriately, Malevich had hung the *Black Square* where the wall met the ceiling, a space known as the "beautiful corner" in Russian and traditionally reserved for religious icons. Today the "Mona Lisa of non-representational art" is housed in the Tretyakov Gallery, Moscow, with a second version in the Hermitage in St. Petersburg.

# BLACK POWER

Black Power was a social movement which emerged in the United States in the 1960s. It emphasized racial pride, economic empowerment, and the creation of political and cultural institutions to better represent African American people. Black Power activists founded black-owned bookstores, printing presses, food cooperatives, and schools. Inspired by Malcolm X, as well as liberation movements in Africa, Asia, and Latin America, Black Power became an important force alongside the mainstream civil rights movement. The term, which has various origins, was popularized as a rallying cry by activist Stokely Carmichael.

# BLACK CATS

There's a lot of superstition surrounding black cats. In Japanese folklore and Celtic mythology, black cats have positive associations with love, prosperity, and good health. Among sailors, black cats were a favorite friend on board, thought to ensure a safe journey at sea. In Britain, Ireland, and Germany it's lucky to see a black cat—so long as it crosses your path from left to right. But in medieval Europe, cats—and black cats above all—became associated with evil, witchcraft, and bad luck. In the 1230s, Pope Gregory IX announced that cats were part of satanic rituals. Some 200 years later, Pope Innocent VIII described the cat as the "devil's favorite animal." Cat burning rituals were sadistic entertainment across western and central Europe.

# GOLD

# TRUE GOLD

Gold stands for permanence, endurance, and the everlasting—like the gold wedding ring. It's been in demand for thousands of years: initially because of its color, its shine, and its suitability as a jewelry material and its ready bonding with other metals. As a means of payment in the form of coins, it replaced bartering and has been used as a currency at different times and in different cultures. Thanks to its non-corrosive properties, gold from ancient Egypt has been preserved to this day, testifying to the importance of this precious metal from the earliest civilizations. Since gold occurs naturally, albeit very rarely in pure form, it was also available without complicated extraction methods. Gold has long been coveted: the golden fleece, the golden calf—already in Greek mythology and in the Bible gold is an object of desire, struggle, and envy.

Since gold stands for wisdom, stability, preciousness, and loyalty, and is bestowed with special powers in many cultures, it's no surprise that it is attributed to a jubilee wedding. Golden weddings have been celebrated since the 17th century and became increasingly mainstream during the 19th century, when the idea of a love marriage, rather than arranged marriage, proliferated. As people started to think about marriage in more sentimental ways, spending such a long time together was considered something very precious—perhaps even more precious than gold. Today, the occasion is marked with festivities and gifts, including gold jewelry, watches, decorations, and golden (yellow) roses.

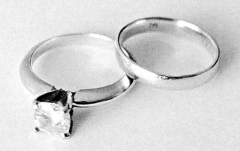

# GOLDEN WEDDING

# BYZANTINE

The use of gold in mosaic art began in Ancient Rome, without any strong religious connotation. By the early Christian period, the material became closely associated with spiritual settings. In the art of the Byzantine Empire in particular, a gold background or "gold ground" became the dominant style for religious mosaic, illuminated manuscripts, and panel paintings. Outstanding examples of the Byzantine style include Hagia Sophia in Istanbul and St. Mark's Basilica in Venice. In the 20th century, Austrian painter Gustav Klimt revived the effect in his so-called "golden period."

# A GILDED CAGE

To be trapped in a gilded cage describes a state of luxury without freedom. It is often used to evoke restrictive social expectation as, for example, when the given etiquette of the rich and powerful prevents an individual doing what they really want. A Chinese proverb speaks to this phenomenon: "A bird prefers a simple branch to a golden cage." One of the most famous ballads from the turn of the 20th century was also dedicated to the subject. The sheet music for *A Bird in a Gilded Cage*, composed by Arthur J. Lamb and Harry Von Tilzer, sold a record two million copies.

# GOLD RUSH

At the end of the 17th century, the Minas Gerais region in Brazil was booming. Gold and diamond finds had attracted prospectors all the way from Europe. Then, on January 24, 1848, American laborer James Wilson Marshall accidentally found a gold nugget while building a mill in the Californian town of Coloma on the American River. The large landowner on whose premises the find was made did not succeed in keeping it a secret: the news spread at lightning speed and sparked an influx that almost overran San Francisco. Between 1846 and 1852, the city grew from a small settlement of about 200 residents to a boomtown of 36,000. Whole indigenous societies were attacked and pushed off their lands. Clothing and food became excessively expensive. But businessmen and traders made a fortune. A total of 570 tons of gold were found in the Californian rivers. The state's nickname—the Golden State—derives from this time.

# SHADES OF GOLD

Gold symbolizes pure opulence—today gold coins and gold bars remain highly-valued assets, widely considered one of the safest investments. As with precious stones, gold is measured in karats. Karats measure the parts per 24, so that 24 karat gold is considered 100 percent gold (or 99.99 percent, since impurities cannot be excluded). The gold's purity has an influence on its color—and its application. Pure gold has the highest price, but it is also relatively soft and unsuitable for many uses. Gold jewelry contains parts of other metals—so-called alloys—including silver, copper, platinum, palladium, or nickel. Compounds with nickel, palladium, or silver result in lighter colors known as white gold. Red gold is made by adding copper, a little silver and sometimes zinc. Today, the gold palette has expanded further to include gray, blue, green, or even black gold.

# GOLDEN

The golden ratio is the division of a line or other size unit into two unequal parts, so that the long part divided by the short part, is also equal to the whole length divided by the long part. Scholars since Euclid have studied this mathematical relationship, which became an ideal of harmony in various areas including art, architecture, and craft. It remains a subject of debate whether forms in the golden ratio—also known as the golden section or golden mean—actually appear more balanced to the human eye. Famous buildings correspondent to the golden ratio, whether intentionally or accidentally, include the Parthenon in Athens or the Cheops Pyramid. Leonardo da Vinci's *Last Supper* and Raphael's *Triumph of Galatea* also incorporate the golden ratio into their compositions.

# RATIO

# GOLD E 175

When it comes to gastronomy, all sorts of food can be gilded for opulent effect. Chocolate, pralines, steaks, and caviar can all be accentuated with gold leaf, otherwise known as food coloring E 175. The coloring is at least 22-carat gold and extracted from rocks containing gold using various methods. It is edible, but only permitted as a coating, decoration, or an additive in spirits. Though safe in low doses, larger quantities of E 175 can cause poisoning. The gold itself has no taste, but lends the impression of a unique and extravagant dish.

# MEDICINAL GOLD

Gold is one of the oldest remedies known to man. The Egyptians believed it brought energy to body and mind. The doctor, alchemist and natural philosopher Paracelsus (1493/4–1541) believed the essence *Aurum potabile*, also known as drinking gold, was a universal elixir of life. The Benedictine abbess Hildegard von Bingen believed that a cure made from pure gold would relieve the symptoms of rheumatism as well as gout. Up until the 1980s, gold injections were still used for severe rheumatoid arthritis, despite some serious side effects including liver and kidney damage. Today, we know that there is a glimmer of scientific truth in medicinal gold. The metal has an anti-inflammatory effect and thus regulates the immune system. Recent experiments have raised hopes for gold-based nano-medicine and treatments for cancer and pathological obesity.

Bees have populated the earth for some 100 million years. As evidenced by cave paintings, people discovered honey as a food as early as the Stone Age. The first written records of beekeeping are from ancient Egypt, where honey was used to sweeten cakes, biscuits, and other foods. The therapeutic uses of honey were also documented in the Vedas and Ayurveda texts of ancient India. Honey is still a popular remedy for external wounds, stomach complaints, and coughs. It does not contain many vitamins and minerals, but does contain antioxidants and bioactive ingredients.

# LIQUID GOLD

# SILVER

# SILVER

A silver wedding anniversary is celebrated after 25 years of marriage. The tradition likely originated in medieval Germany where, if a married couple lived to celebrate the 25th anniversary of their wedding, the wife was gifted with a silver wreath. Today, the occasion is often marked with a lively celebration and the exchange of silver jewelry—an appropriately enduring material. In monarchies, a Silver Jubilee marks 25 years of reign.

# WEDDING

Among the great apes, also known as the biological family of *Hominidae*, gorillas and humans are among the largest representatives. Native to sub-Saharan Africa, gorillas are divided into two species—eastern and western gorillas—and at least two subgroups: the western lowland and cross-river gorilla and the eastern lowland and mountain gorilla. Adult male gorillas acquire their silver-gray coat at around 12 years' old. A dominant silverback leads a group of adult females and youngsters, numbering anywhere between four and forty animals in total, depending on the subspecies. The lead silverback ensures the safety of the group, determines the direction of foraging and has the respect of all group members. If male gorillas leave the group around the age of 11, there is no rivalry over leadership. Sometimes, however, the non-dominant silverbacks continue to live in the community and, at the appropriate moment, take over the group that would otherwise disintegrate when the leader dies.

SILVERBACK

# RICH MOUNTAIN

It was likely by chance that Diego Huallpa, of the indigenous Quechua people, discovered a silver vein in Cerro Rico (Rich Mountain) in the Bolivian Andes in 1545. The city of Potosi, located at the foot of the mountain at almost 4,100 meters (13,450 feet), suddenly became the center of the world—and later a UNESCO World Heritage Site. The Spanish conquerors forced the indigenous population to work in the mines while profiting off the new source of prosperity. In just 30 years, more silver was extracted from the Potosi mines than was in circulation across all of Europe. Potosi coins were accepted around the world. There is even a theory that the dollar sign emerged from the Potosi mint mark. The silver mining caused unimaginable suffering and numerous fatalities. No wonder that locals called Cerro Rico "la montaña que come hombres," "the mountain that eats people." By the 19th century, all silver reserves had been extracted. Nowadays the area is mined for tin, copper, zinc, and lead.

# SILVER COINS

Ever since man was able to mine and process precious metals such as silver and gold, they have been used as a means of payment. Silver shekels—a weight consisting of 8.33 grams of silver—were in use some 4,500 years ago. Minted silver coins have been around since 550 BC, originating in Greece and Asia Minor. The advantage of coins over weights was that they could be easily counted. Silver coins must contain at least 50 percent silver. Since pure silver would have been too soft and malleable for circulation, copper was usually added. In the first half of the 20th century, many countries drew silver coins, among other things, out of circulation due to fluctuating silver prices and inflation. Today, only special and commemorative coins are produced in silver.

# SPACE AGE

Over the course of the 20<sup>th</sup> century, with advancing machinery and increased use of sophisticated metals, the color silver became strongly associated with technological advance, most particularly space travel. Beginning with the launch of Sputnik 1 in 1957, the Space Age ushered in a new era of politics, science, style—and color palette. Product designers created chairs and lights in silver-colored surfaces. Fashion designers created silver tunics, accessorized with silver gloves and boots. Car designers, too, turned to rocket-like forms and gleaming silver fittings—as if the vehicle might lift off any moment.

# SILVER SCREEN

A silver screen is a type of projection screen that was widely used in the early years of the motion picture industry. The term comes from the actual silver, or silver-colored aluminum, embedded in the screen's highly reflective surface. The screen was invented by Ohio projectionist Harry Coulter Williams. While no longer used in standard movie houses, the term "silver screen" still refers to the cinema and the movie industry more widely.

# ALUMINUM FOIL

Though silver in color, the staple foil of food storage is made from pure aluminum. It was developed by the Swiss entrepreneur Heinrich Alfred Gautschi, who received the manufacturing patent in 1905, using the packet rolling process. In this, an aluminum sheet was repeatedly rolled, divided, laid one on top of the other, and rolled again until there were 64 layers—small in both length and width. In 1910, Robert Victor Neher, Erwin Lauber and Albert Gmür developed a more advanced process that made it possible to roll out longer sheets.

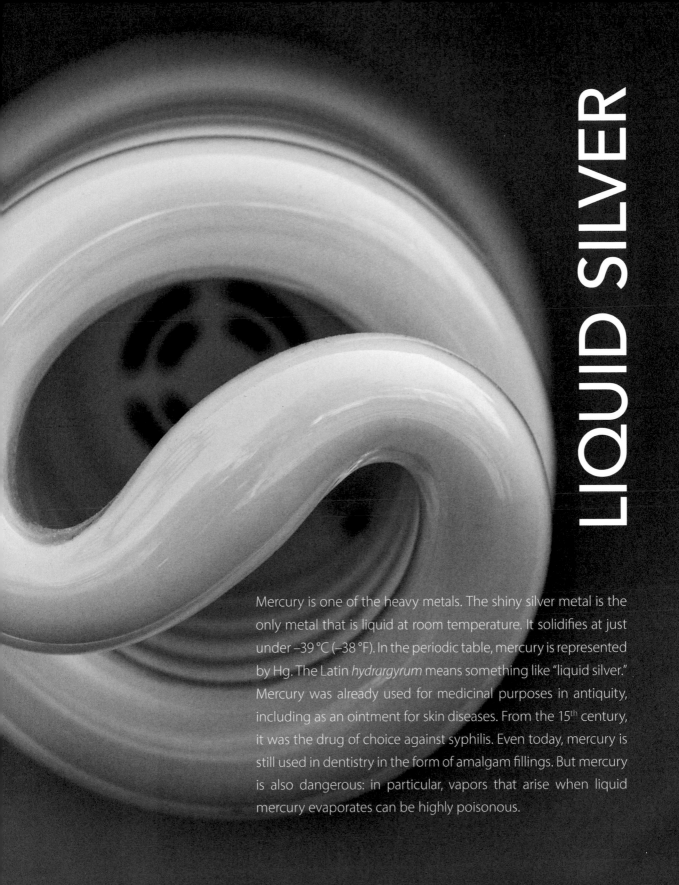

# LIQUID SILVER

Mercury is one of the heavy metals. The shiny silver metal is the only metal that is liquid at room temperature. It solidifies at just under −39 °C (−38 °F). In the periodic table, mercury is represented by Hg. The Latin *hydrargyrum* means something like "liquid silver." Mercury was already used for medicinal purposes in antiquity, including as an ointment for skin diseases. From the 15th century, it was the drug of choice against syphilis. Even today, mercury is still used in dentistry in the form of amalgam fillings. But mercury is also dangerous: in particular, vapors that arise when liquid mercury evaporates can be highly poisonous.

# TABLEWARE

Already in Ancient Greece, silver had a representational function at the dinner table, distinguishing an upscale household. The term refers not only to cutlery, but to all the silver that comes onto the table for special occasions: dishes, platters, bowls, salt and pepper shakers, and decorative objects such as candlesticks. Through industrialization, it became possible for the upper bourgeoisie to also buy silverware. For many people, the family silver still holds both material and emotional value, and is passed on from generation to generation.

# MOON METAL

If one thinks of Ancient Egypt, one typically thinks of golden death masks and golden jewels. Indeed, gold is almost the defining color of Ancient Egypt—and there was plenty of it along the Nile. Silver, on the other hand, was rare and only found in the underdeveloped Sinai Peninsula. For Ancient Egyptians, silver was therefore considered even more rare and valuable—until new trade routes made the latter easier to import. In Egyptian culture, it was known as "moon metal." Fittingly, the moon remains an alchemical symbol for silver to this day.

# MULTICOLOR

# HOLI

When a colorful cloud of paint hovers over India, water is sprayed and people dance through the streets, it's Holi. The Hindu Spring Festival begins with the symbolic burning of the demon Holika and continues on the second day, Rangwali Holi, with the throwing of colored powder. Originally, the event celebrated fertility and harvest, occurring in the first quarter after the full moon of Phalguna, the 12th month in the Hindu calendar and correspondent to February/March in the Gregorian calendar. Nowadays, the festival unites various legends of Hinduism, including Holika and King Prahlāda, her nephew, and pays homage to the major deity Krishna. The celebrations can last up to 16 days. During this time, barriers of caste, gender, skin color, age, and origin seem to dissolve. Revelers eat sweet dumplings called *gujiyas* and drink cannabis milk. The colored powder, *gulal*, with which everyone and everything is colored (even animals are not spared), was originally made from flowers, spices, and roots. Sometimes it even had positive properties in addition to its color symbolism. Today, the synthetic dyes come from China and, like fine dust, are rather hazardous to health.

# OPAL

The special feature of opal is undoubtedly its ambiguous color scheme, forever shifting between tones of white, blue, green, red, black, yellow, and translucence, depending on ones perspective. For all its rainbow diversity, the stone belongs to the class of oxides and hydroxides and has no crystal structure. It is believed that the name opal comes from the old Sanskrit term *upala*, which means precious stone. Pliny the Elder (23–79 AD) already appreciated the gemstone's variety: "... It shows the fire of the ruby, the purple brilliance of the amethyst and the sea green of the emerald at the same time. All of this merged into one another and in an unbelievable clarity." Australia, which has large deposits in the Great Artesian Basin area, supplies up to 95 percent of the world's opal. Residue from the Jurassic and Cretaceous Period created the prerequisites for opal formation which, according to different theories, took anywhere between 30 and 100 million years.

# RAINBOW
# BUTTERFLY

The diurnal Madagascar Sunset Moth (*Chrysiridia rhipheus*) is native to Madagascar and one of the most colorful butterflies in the world. Its wings have a deep black base color on the upper side with greenish stripes in the upper area and lower shimmers in shades of green, orange, violet, pink, and yellow. On closer inspection, it is the wing's surface structure that actually refracts light in different ways and produces the impressive color spectrum that made the Madagascar Sunset Moth a coveted collector's item. The butterfly is endangered by increasing destruction of its habitat, which mainly consists of tropical forests.

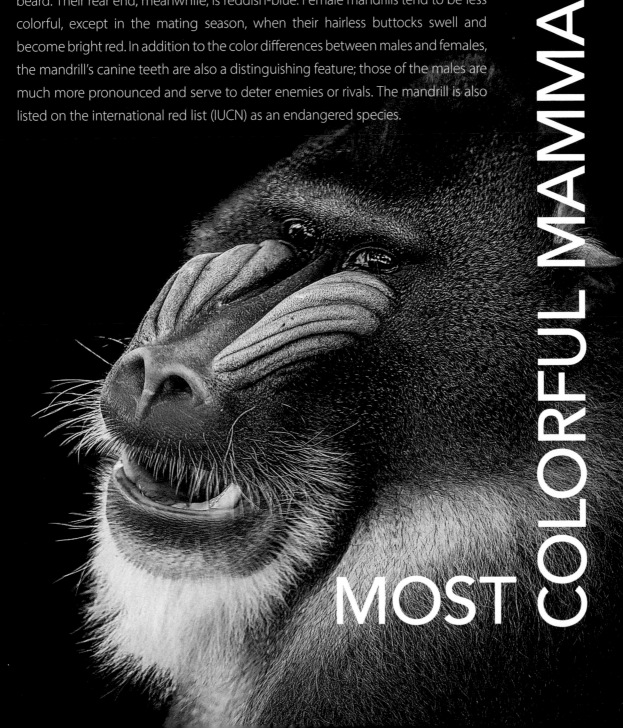

The mandrill, the world's largest monkey, resides in the evergreen tropical rain-forests and mountain forests of Central Africa. It stands out not only because of its size but also its unusual color combination. Dominant mandrill males in particular boast a red nose, bony light blue furrows running down the nostrils, and a yellow beard. Their rear end, meanwhile, is reddish-blue. Female mandrills tend to be less colorful, except in the mating season, when their hairless buttocks swell and become bright red. In addition to the color differences between males and females, the mandrill's canine teeth are also a distinguishing feature; those of the males are much more pronounced and serve to deter enemies or rivals. The mandrill is also listed on the international red list (IUCN) as an endangered species.

# MOST COLORFUL MAMMAL

# IRIDESCENT OIL

Iridescent color patterns occur when gasoline or oil meets water. But why does this phenomenon exist? In fact, the oil or gasoline does not mix with the water, but remains on the surface as a thin film. This does not change even if the water is stirred, since the oil has a lower density and remains lighter. If sunlight hits the surface of the oil film, part of the light is refracted by the oil, while another part passes through the oil film and is refracted at the water surface. The splitting creates a rainbow effect, albeit a different color variety than in a prism or rainbow itself.

# RAINBOW

The rainbow has long puzzled humans. Ancient legends attributed the natural phenomenon to the gods. Irish folklore speculated that at the end of the rainbow there was a pot full of gold. Unfortunately, this is not the case, because a rainbow has no end. It is, in fact, a circle. Since the 1950s, rainbows have been classified according to the size of raindrops through which the sunlight fractures, fans out, and reflects the spectral colors. The theory ran that the bigger the raindrops, the more intense the rainbow colors. For scientist Jean Ricard and his colleagues, the position of the sun was actually more decisive. In a 2015 study, they developed 12 different categories of rainbow, depending on which colors are seen, whether there is a second rainbow in reverse color order, and whether a dark stripe, also called "Alexander's band", appears between the two.

# COLORFUL AND NUTRITIOUS

Even children know that an ideal diet should include five servings of fresh fruit and vegetables a day. Nutritionists go further, recommending eating a rainbow a week. This means including the entire color spectrum of fruits and vegetables, because they contain a variety of health-promoting plant pigments. For example chlorophyll (green) favors the absorption of iron, while anthocyanins (violet and blue) have anti-inflammatory effects, and carotenoids (red, orange, and yellow) stimulate metabolism as well as digestion. A colorful mix has become a key characteristic of a balanced diet.

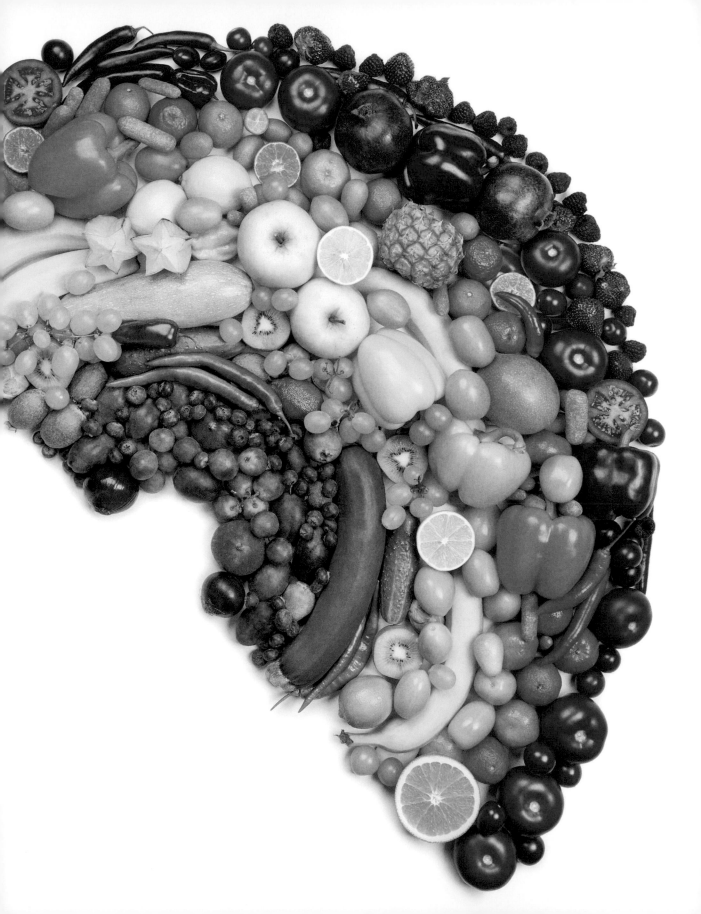

# COLOR TELEVISION

In most parts of the world, television stations and networks upgraded from black-and-white to color transmission between the 1960s and the 1980s. Experiments in color image began almost as soon as the black-and-white television had been built. In 1897, Polish inventor Jan Szczepanik patented a color system. Armenian engineer, Hovannes Adamian, also experimented with color as early as 1907. But it wasn't until 1928 that Scotsman John Logie Baird demonstrated the first successful color transmission, later developing the trailblazing "Telechrome" system. Color broadcasting was standardized in Europe in the 1960s with the Phase Alternating Line (PAL) format. Today, almost all countries that used PAL are converted, or converting, to digital television.

# PRIDE
# FLAG

The rainbow flag is a symbol of tolerance and diversity around the world and has been associated with the LGBTQ community in particular since the 1970s. In 1978, on the advice of the first openly gay US politician, Harvey Milk, American designer Gilbert Baker designed a positive symbol for the Pride movement and Gay Freedom Day in San Francisco. The original version of the flag consisted of eight colors, including pink and turquoise. Since pink dye could not yet be industrially manufactured and the flag needed an even number of stripes to be evenly spread along the parade route, turquoise was excluded alongside pink. Each color in the original flag had its own symbolism: pink stands for sexuality, red for life, orange for health, yellow for sunlight, green for nature, turquoise for art, blue for harmony, and purple for spirituality.

When it comes to corporate design, the nibbled apple is one of the most readily-identified logos in the world. It was designed by Rob Janoff in 1977, but only devoted tech fans know that the Apple apple was originally designed in rainbow colors. The colorful version appeared shortly before the Apple II home computer, the world's first with a color display, and Janoff took up the novelty in his logo. The apple has changed several times over the years and has not been multicolored since 1998.

# RAINBOW LOGO

# APPENDIX

> ## "COLOR IS NOT AN INVENTION, IT IS A PHENOMENON."
>
> Joanna Zoelzer, 2018

**Joanna Zoelzer** was born in 1978 in Katowice, Poland and moved to Munich with her parents and sister in 1987. As a child, she attended an art school in her hometown, where she practiced painting and design with enthusiasm and discovered her fascination for colors at an early age. Joanna studied graphic design at the Faber-Castell Academy in Stein near Nuremberg from October 2015 to March 2019, graduating with a Bachelor of Arts. In her thesis, she dealt intensively with the phenomenon of color. She lives with her family in Ismaning near Munich and works as a freelance graphic designer and artist. Her work has been featured in several art exhibitions and design competitions.

**Eliza Apperly** is a writer, editor, and producer, based in Berlin. She studied French and Italian at the University of Cambridge and Art History at the Courtauld Institute in London. Formerly Online Editor at Taschen, Eliza has reported on arts, culture and politics for *The Guardian*, *The Atlantic*, *Reuters*, *BBC*, *Aeon*, and *The Art Newspaper*.

# IMAGE CREDITS

# BIBLIOGRAPHY

Adams, Sean. *The Designer's Dictionary of Color*, Harry N. Abrams, 2017

Bartel, Stefanie. *Farben im Webdesign: Symbolik, Farbpsychologie, Gestaltung*, Springer, 2003

Blackman, Cally. *100 Jahre Fashion*, Prestel Verlag, 2012

Böhringer, Joachim et al. *Kompendium der Mediengestaltung: I. Konzeption und Gestaltung*, Springer Vieweg (6. Auflage), 2014

Böhringer, Joachim et al. *Kompendium der Mediengestaltung: II. Medientechnik*, Springer Vieweg (6. Auflage), 2014

Braem, Harald. *Die Macht der Farben: Bedeutung & Symbolik*, Wirtschaftsverl. Langen Müller/Herbig, 2009

Coles, David. *Farbpigmente: 50 Farben und ihre Geschichte*, Haupt Verlag, 2019

Cruschiform. *COLORAMA. Das Buch der Farben*, Prestel Verlag, 2017

Delamare, Francois und Guineau, Bernard. *Colour: Making and Using Dyes and Pigments: New Horizons*, Thames & Hudson, 2000

Dior, Christian. *Das kleine Buch der Mode*, Eden Books, 2014

Düchting, Hajo. *Wie erkenne ich? Meisterwerke der Moderne*, Belser Verlag, 2008

Ebert, Johannes et al. *Die Chronik: Geschichte des 20. Jahrhunderts bis heute*, Chronik Verlag im Wissen Media Verlag, 2006

Eckstut, Joann und Eckstut, Arielle. *The Secret Language of Color: Science, Nature, History, Culture, Beauty of Red, Orange, Yellow, Green, Blue & Violet*, Black Dog & Leventhal, 2013

Eiseman, Leatrice und Recker, Keith. *Pantone: Farbe in Kunst und Leben*, DuMont, 2011

Eiseman, Leatrice. *The Complete Color Harmony, Pantone Edition: Expert Color Information for Professional Results*, Rockport Publishers, 2017

Finlay, Victoria. *Das Geheimnis der Farben: Eine Kulturgeschichte*, List, 2004

Finlay, Victoria. *Colours: Die Geschichte der Farben*, Theiss, Konrad, 2015

Fraser, Tom und Banks, Adam. *Farbe im Design: Das umfassende Kompendium zur Gestaltung mit Farbe*, Taschen, 2005

Gage, John. *Kulturgeschichte der Farbe: Von der Antike bis zur Gegenwart*, Seemann Henschel, 2010

Glasner, Barbara und Schmidt, Petra (Hrsg.). *Chroma: Design, Architektur & Kunst in Farbe*, Birkhäuser, 2009

Heller, Eva. *Wie Farben wirken: Farbpsychologie, Farbsymbolik, Kreative Farbgestaltung*, Rowohlt, 1989

Heller, Eva. *Wie Farben auf Gefühl und Verstand wirken: Farbpsychologie, Farbsymbolik, Lieblingsfarben, Farbgestaltung*, Droemer, 2000

Itten, Johannes. *Kunst der Farbe: Subjektives Erleben und objektives Erkennen als Wege zur Kunst*, Otto Maier Verlag, 1998

Jarman, Derek. *Chroma: Ein Buch der Farben*, Merve-Verlag, 1995

Kastan, David Scott und Farthing, Stephen. *On Color*, Yale University Press, 2019

Kraaz von Rohr, Ingrid. *Farbtherapie: Das Basiswissen über Wirkung und Anwendung der Farben*, Nymphenburger, 2003

Küppers, Harald. *Farbe verstehen und beherrschen: Praktische Farbenlehre*, DuMont, 2004

Küppers, Harald. *Einführung in die Farbenlehre*, DuMont, 2016

Ott, Gerhard und Proskauer, Heinrich O. (Hrsg.) *Goethe Farbenlehre, Bd.1, Bd.4, Bd.5*, Verlag Freies Geistesleben, 2003

Roth, Günther D. *Sterne und Planeten*, BLV, 2005

St Clair, Kassia. *Die Welt der Farben*, Hoffmann und Campe Verlag, 2017

Syme, Patrick. Werner's *Nomenclature of Colours: Adapted to Zoology, Botany, Chemistry, Mineralogy, Anatomy, and the Arts*, Smithsonian Institution, 2018

Tan, Jeanne et al. *Colour Hunting: How Colour Influences what We Buy, Make and Feel*, Frame Publishers, 2011

Vollmar, Klausbernd. *Das große Buch der Farben*, Königsfurt-Urania Verlag, 2017

Vollmar, Klausbernd. *Farben Symbolik, Wirkung, Deutung*, Knaur, 2009

Wäger, Markus. *Das ABC der Farbe: Theorie und Praxis für Grafiker und Fotografen*, Rheinwerk Verlag, 2017

Welsch Norbert und Liebmann Claus Chr. *Farben: Natur, Technik, Kunst, Spektrum*, Akad. Verlag, 2003

Werkner, Patrick. *Kunst seit 1940: Von Jackson Pollock bis Joseph Beuys*, UTB, 2007

Wolf, Isabelle. *Was Farben sagen: Die Sprache der Farben verstehen und gekonnt einsetzen in Einrichtung und Mode*, Goldmann, 2011

## WEB

Brillux GmbH & Co. KG: Das Onlineportal für Farbe in Wissenschaft und Praxis, www.farbimpulse.de

Immos, Franz: *Bedeutung der Farben*, gestaltung.wilhelm-ostwald-schule.de/wp-content/uploads/2010/04/bedeutung-der-farben.pdf

Immos, Franz: *Energetik der Farbe*, franz.immoos.eu/farbenergie

NASA: nasa.gov

National Geographic: nationalgeographic.com

Seilnacht, Thomas: *Farbe erleben*, www.seilnacht.com

Stadler, Marlene: *Farben und Leben-Online, Das Portal für Farben und Farbwirkung*, www.farbenundleben.de

## FOREWORD

Bladowski, B. & Maus, D. – Universität Mannheim. *Farbwahrnehmung*, irtel. unimannheim.de/lehre/seminararbeiten/w96/Farbe/seminar.htm

Scholtyßek, C. & Kelber, A. *Farbensehen der Tiere. Von farbenblinden Seehunden und tetrachromatischen Vögeln*, In: *Der Ophthalmologe*, 2017, 114:978–985

## WHITE

The White House: *History of the White House*, www.whitehouse.gov/about-the-white-house/the-white-house/

## YELLOW

archeologie.culture.fr/lascaux/en

Fabry, Merrill (02 May 2017). *Now You Know: Why Are Taxi Cabs Yellow?*, time.com/4640097/yellow-taxi-cabs-history/

Schaller Consulting. *The New York City Taxicab Fact Book*, www.schallerconsult.com/taxi/taxifb.pdf

## ORANGE

Hermès International: *Die orangefarbene Schachtel steckt voller Ressourcen*, www.hermes.com/de/de/story/135816-resourceful-orange-box-de/

## RED

Bennett, J. et al. *Astronomie, Die kosmische Perspektive*, Pearson Studium, 2010

Deutsche Physikalische Gesellschaft e.V.: *Infrarot; Ultraviolett*, www.weltderphysik.de

Diez, Anja et al. *Liquid water on Mars*, In: *Science*, 2018, Vol. 361, Issue 6401:448–449

Merrison, J.P. et al. *Mineral alteration induced by sand transport: A source for the reddish color of martian dust*, In: *Icarus*, 2010, Vol. 205, Issue 2:716–718

Theroux, Alexander. *Rot: Anleitungen eine Farbe zu lesen*, Europäische Verlagsanstalt, 1998

## PINK

Blackwell, B. et al. *Demonstration to medical students of placebo responses and non-drug factors*, In: *Lancet*, 1972, Vol. 1, Issue 7763:1279-82

Bunn, Rex & Nolden, Sascha. *Forensic cartography with Hochstetter's 1859 Pink and White Terraces survey: Te Otukapuarangi and Te Tarata*, In: *Journal of the Royal Society of New Zealand*, 2018, Vol. 48, Issue 1:39–56

Buschek, Nina & Müller, Ingrid. *Medikamenten-Farbe*, (27 May 2014), www.netdoktor.de/medikamente/medikamenten-farbe/

Hein, Till. Farbtherapie: *Pink macht mild statt wild*, (05 February 2012), www.derstandard.at/story/1328162449775/farbtherapie-pink-macht-mild-statt-wild

Heine, Matthias. *Als richtige Jungen noch Rosa trugen*, (21 April 2011), www.welt.de/print/die_welt/politik/article13232160/Als-richtige-Jungen-noch-Rosa-trugen.html

Schauss, Alexander G. *The Physiological Effect of Color on the Suppression of Human Aggression: Research on Baker-Miller Pink*. In: *International Journal of Biosocial Research*, 1985, Vol. 7, Issue 2:55–64

Simon, Anne-Catherine. *Farbgeschichte: Rosa, die umstrittenste Farbe der Welt*, (22 May 2013), www.diepresse.com/1408595/farbgeschichte-rosa-die-umstrittenste-farbe-der-welt

## PURPLE

Cartwright, Mark. *Tyrian Purple*. World History Encyclopedia, www.worldhistory.org/Tyrian_Purple/

Grovier, Kelly. *Tyrian Purple: The disgusting origins of the colour purple*, www.bbc.com/culture/article/20180801-tyrian-purple-the-regal-colour-taken-from-mollusc-mucus

Hochweis, Olga. *Die Farbe Violett. Schillernde Vielfalt*, (02 December 2018), www.deutschlandfunkkultur.de/die-farbe-violett-schillernde-vielfalt.2193.de.html?dram:article_id=434802

*Symbols of the Women's Suffrage Movement*, www.nps.gov/articles/symbols-of-the-women-s-suffrage-movement.htm

## BLUE

Gelder, Russell N. Van. *Non-Visual Photoreception: Sensing Light without Sight*, In: *Current Biology*, 2008, Vol. 18, Issue 1:R38-R39, doi.org/10.1016/j.cub.2007.11.027

Hertrampf, Iris. *Wirkung und Funktion der Farbe bei Yves Klein*. Magisterarbeit. Goethe-Universität Frankfurt am Main, 2008, d-nb.info/1046823051/34

Verbraucherzentrale NRW e.V.: *Spirulina – Viel Grün und wenig dahinter* (28 September 2020), www.verbraucherzentrale.de/wissen/lebensmittel/nahrungsergaenzungsmittel/spirulina-viel-gruen-und-wenig-dahinter-21053

Wietig C. et al. *Kulturgeschichtliche Aspekte heller Haut*, In: Jung E.G. (eds) *Kleine Kulturgeschichte der Haut*, Steinkopff, 2007, S. 120–125

YouGov Deutschland GmbH: *Blau ist die häufigste Lieblingsfarbe – nicht nur in Deutschland* (30 April 2015), yougov.de/news/2015/04/30/blau-ist-die-haufigste-lieblingsfarbe-nicht-nur-de/

The New York Times. *Lapislazuli and the history of the most perfect color*, www.nytimes.com/2015/08/19/arts/international/lapis-lazuli-and-the-history-of-the-most-perfect-color.html

## TURQUOISE

NABU – Naturschutzbund Deutschland e.V.: *Pummeliger Edelstein und geschickter Jäger. Ein kurzer Steckbrief des Eisvogels*, www.nabu.de/tiere-und-pflanzen/aktionen-und-projekte/vogel-des-jahres/2009-eisvogel/10120.html

Röll, Beate. *Der Türkisblaue Zwerggecko: Lygodactylus Williamsi*, Natur und Tier (Verlag), 2014

Stadler, Martin Andreas. *Ein „vollkommenes Gesicht" aus dem spätptolemäischen Ägypten. Zu einer Mumienmaske des Martin von Wagner Museums*, In: Maier, M. und Specht, St. (Hg.). *Blickwechsel. 10 Jahre Museumsinitiative des Martin von Wagner Museums*, Ergon-Verlag, 2001, S.145–164

Tiffany & Co.: *Die Tiffany Blue Box®*, www.tiffany.com/world-of-tiffany/blue-box-story/

Turqoise (mineral), In: Wikipedia, The Free Encyclopedia (07 June 2021), en.wikipedia.org/wiki/Turquoise

## GREEN

Chrom(III)-oxid (inorganic compound). In: Wikipedia – The Free Encyclopedia, (03 April 2021), en.wikipedia.org/wiki/Chromium(III)_oxide

www.kroschke.com/sicherheitskennzeichen-schilder--n-02.html

## BROWN

Bundesverband der Deutschen Süßwarenindustrie e.V.: *Alles über Schokolade*, schokoinfo.de

Deutscher Kaffeeverband e.V.: *Die Geschichte des Kaffees*, www.kaffeeverband.de/de/kaffeewissen/geschichte

Edelkoort, Li. *Brown is the New Grey*. Lifestyle und Fashion Trends 2020 / 21, edelkoort.ch/

Gebhardt, Philine. *Siegeszug der Sonnenanbeter*, (24 July 2018), www.spiegel.de/geschichte/braeune-als-schoenheitsideal-siegeszug-der-sonnenanbeter-a-1215465.html

Paál, Gábor. *Älteste Höhlenmalerei der Welt in Indonesien entdeckt*, (15 January 2021), www.swr.de/swr2/wissen/aelteste-hoehlenmalerei-der-welt-entdeckt-102.html

Spieler, Sabine. *Warum Braun das neue Schwarz ist*, (14 January 2020), www.faz.net/aktuell/stil/mode-design/farbtrends-warum-braun-das-neue-schwarz-ist-16576798.html

United Parcel Service of America, Inc.: *Mehr als 100 Jahre Innovation*, about.ups.com/de/de/our-company/our-history.html

## GRAY

Pantone LLC: *Mehr Farben, mehr Möglichkeiten*, www.pantone.com/eu/de/artikel/product-spotlight/mehr-farben-mehr-moglichkeiten

Paschek, Nicole. *Sind die „grauen Zellen" wirklich grau?* (26 August 2016), www.spektrum.de/frage/sind-die-grauen-zellen-wirklich-grau/1421089

Zhang, B. et al. *Hyperactivation of sympathetic nerves drives depletion of melanocyte stem cells*, In: Nature 577, 676–681, 2020. doi.org/10.1038/s41586-020-1935-3

## BLACK

Bundeszentrale für politische Bildung: *80 Jahre „Schwarzer Freitag"*, (23 October 2009), www.bpb.de/politik/hintergrund-aktuell/69271/80-jahre-schwarzer-freitag-23-10-2009

Goth subculture, on: Wikipedia, The Free Encyclopedia (22 July 2021), en.wikipedia.org/wiki/Goth_subculture

Hakemi, Sara. *Schwarz wie die Nacht. Das kleine Schwarze*, In: Kaiser, Alfons und Kusicke, Susanne (Hrsg.). *Poncho, Parka, Prada-Täschchen. Kleines Glossar der unentbehrlichen Kleidungsstücke*, H.C. Beck, 2006, S. 29–33.

Reynolds, Simon. *Rip it Up and Start Again, Postpunk 1978–1984*, Faber & Faber, 2005

Seeling, Charlotte. Mode. *Das Jahrhundert der Designer 1900–1999*, Ullmann, 1999

Tuchmann, Barbara. *A Distant Mirror – The Calamitous 14th Century*, New York 1978

## GOLD

Corbalán, Fernando: *Der Goldene Schnitt. Die mathematische Sprache der Schönheit*, Librero, 2016

Fabry, Merrill. *Now You Know: Why Are There Special Gifts for Each Anniversary Year?*, time.com/4771179/history-anniversary-gifts-paper-silver-gold/

Rackow-Freitag, Bettina. *Gold als Heilmittel*, (13 February 2019), www.apotheken-umschau.de/medikamente/basiswissen/gold-als-heilmittel-721063.html

The American Dream – US GreenCard Service GmbH: *Der amerikanische Goldrausch*, www.info-usa.de/der-amerikanische-goldrausch/

## SILVER

Albat, Daniela. *Quecksilber, Wundermetall und gefürchtetes Gift*, www.scinexx.de/service/dossier_print_all.php?dossierID=206144

Becker, Thomas. *Zum Silberberg von Potosí*, (14 July 2019), www.deutschlandfunk.de/bolivien-zum-silberberg-von-potosi.1242.de.html?dram:article_id=453776

Fabry, Merrill. *Now You Know: Why Are There Special Gifts for Each Anniversary Year?*, time.com/4771179/history-anniversary-gifts-paper-silver-gold/

*Hochzeitstage und ihre Bräuche*, (14 July 2016), www.ln-online.de/Thema/F/Freizeit/Heiraten-in-Luebeck-und-Umgebung/News/Hochzeitstage-und-ihre-Braeuche

Krampitz, Dirk. *Silber war das Gold der alten Ägypter*, (26 September 2014), www.bz-berlin.de/berlin/silber-war-das-gold-der-alten-aegypter

WWF Deutschland: *Portrait der Gorillas*, www.wwf.de/themen-projekte/bedrohte-tier-und-pflanzenarten/gorillas/portrait-der-gorillas

## MULTICOLOR

Adams, Peter; Ricard, Jean; Barckicke, Jean. *Classification of Rainbows*, In: Geophysical Research Abstracts, 2016, Vol. 18, EGU2016-14180, meetingorganizer.copernicus.org/EGU2016/EGU2016-14180.pdf

Bednarz, Christine. *9 Fakten zum farbenfrohen Holi-Fest*, (11 March 2020), www.nationalgeographic.de/geschichte-und-kultur/2020/03/9-fakten-zum-farbenfrohen-holi-fest

Jaeggi, Peter. *Der Opal – Auf den Spuren eines Edelsteins*, (31 August 2010), www.swr2.de

Rainbow flag, on: Wikipedia, The Free Encyclopedia, (18 July 2021), en.wikipedia.org/wiki/Rainbow_flag

Schwake, Vanessa. *Essen nach Farben des Regenbogens*, (05 September 2016), www.vogue.de/gourmet/wirkung-pflanzenfarbstoffe

The Logo Creative. *Apple Logo Evolution—It all Started With a Fruit*, (10 August 2018), thelogocreative.medium.com/apple-logo-evolution-it-all-started-with-a-fruit-e976427f5292

Umwelt-Bundesamt. *Holi – Das Fest der Farben und des Feinstaubs*, (06 January 2021), www.umweltbundesamt.de/themen/gesundheit/umwelteinfluesse-auf-den-menschen/holi-festivals-color-runs

Wissenschaft im Dialog. *Warum sieht der Raum oberhalb eines Regenbogens immer dunkler aus als der darunter?*, (21 August 2014), www.wissenschaft-im-dialog.de/projekte/wieso/artikel/beitrag/warum-sieht-der-raum-oberhalb-eines-regenbogens-immer-dunkler-aus-als-der-darunter/

© 2021 teNeues Verlag GmbH

Concept & Texts by Joanna Zoelzer
Texts on pages 20, 24, 30, 67, 77, 85, 88, 95, 98, 128,
129, 141/2, 152, 154, 155, 161, 170, 173, 180/1, 197, 199
by Eliza Apperly
Translation by Eliza Apperly
Editorial coordination by Nadine Weinhold
Proofreading by Nadine Weinhold, Stephanie Rebel
Production by Sandra Jansen-Dorn
Cover Design by Wolfram Söll, designwerk
Design and Color Separation by Robert Kuhlendahl

LOC 2021935371
ISBN 978-3-96171-365-3
Printed in Slovakia by Neografia a.s.

Bibliographic information published by the
Deutsche Nationalbibliothek: The Deutsche
Nationalbibliothek lists this publication in the
Deutsche Nationalbibliografie; detailed bibliographic
data are available on the Internet at dnb.dnb.de.

Published by teNeues Publishing Group

teNeues Verlag GmbH
Werner-von-Siemens-Straße 1
86159 Augsburg, Germany

Düsseldorf Office
Waldenburger Str. 13
41564 Kaarst, Germany
e-mail: books@teneues.com

Augsburg/München Office
Werner-von-Siemens-Straße 1
86159 Augsburg, Germany
e-mail: books@teneues.com

Berlin Office
Lietzenburger Str. 53
10719 Berlin, Germany
e-mail: books@teneues.com

Press Department Stefan Becht
Phone:  +49-152-2874-9508 /
+49-6321-97067-97
e-mail: sbecht@teneues.com

teNeues Publishing Company
350 Seventh Avenue, Suite 301
New York, NY 10001, USA
Phone: +1-212-627-9090
Fax: +1-212-627-9511

www.teneues.com

teNeues Publishing Group
Augsburg / München
Berlin
Düsseldorf
London
New York

MIX
Paper from
responsible sources
FSC® C020353
FSC
www.fsc.org

teNeues